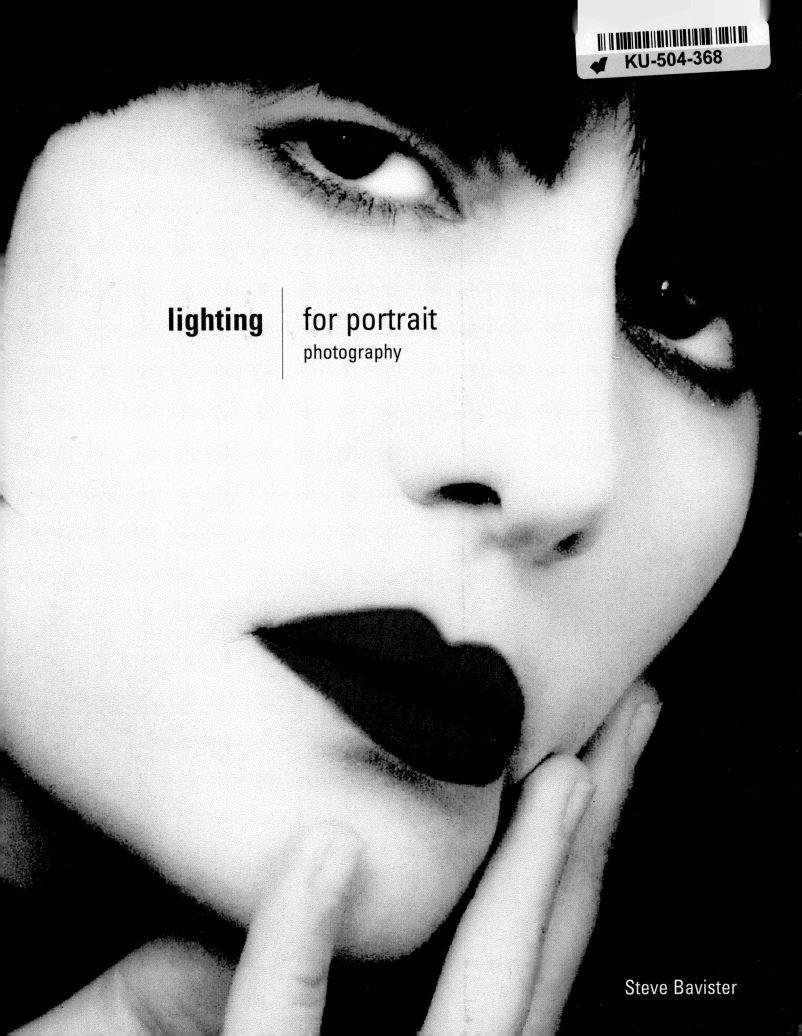

lighting | for portrait
photography

Steve Bavister

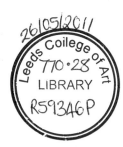

A RotoVision Book
Published and distributed by
RotoVision SA, Rue du Bugnon 7
CH-1299 Crans-Près-Céligny
Switzerland

RotoVision SA, Sales, Production & Editorial Office
Sheridan House, 112/116A Western Road
Hove, East Sussex BN3 1DD, UK

Tel: +44 (0)1273 72 72 68
Fax: +44 (0)1273 72 72 69
E-mail: sales@rotovision.com
Website: www.rotovision.com

ISBN 2–88046–527–3

10 9 8 7 6 5 4 3 2

Book design by Red Design

Production and separations in Singapore by ProVision
Pte. Ltd.

Tel: +65 334 7720
Fax: +65 334 7721

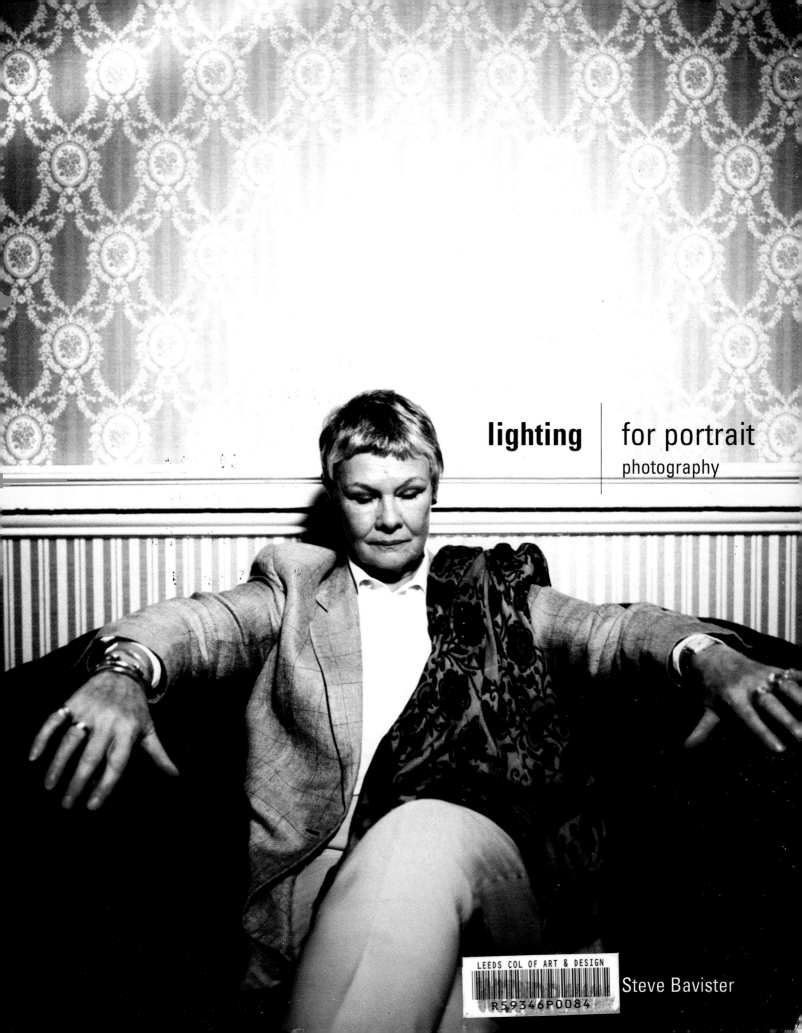

lighting | for portrait
photography

Steve Bavister

contents

lighting...

From the very first pictures captured on wet plates by Victorian pioneers to the latest images recorded as digital files on a computer, people have always been the most popular subject for photography. For amateur snappers, the most common reason for taking out their cameras is to record for posterity, both the individuals who are important to them, and the special moments of their life. In the world of professional photography, too, portraits represent a significant proportion of the work commissioned.

But what do we mean by a 'portrait'? The Collins English Dictionary states it is a 'likeness of an individual, especially of the face'. But while that definition is certainly one with which many would agree, it doesn't really do justice to the multitude of ways in which people can be portrayed in a picture. As the images in the book demonstrate, this is one of the most creative areas of photography you can be involved in.

the portrait market

Unfortunately, one of the largest markets for portraits is not renowned for being original in its approach. What has been considered 'Social' photography – pictures of the children to hang on the wall, engagement and christening shots, family groups and, of course, the wedding album – has a reputation for being bland, formulaic and uninspired. And while times are changing, with an increasing number of studios offering a more imaginative menu of shots, it's fair to say that the majority are still producing work of a traditional nature. Social photography, while important and demanding, is not what this book is about.

6

This book will examine some of the more innovative approaches being taken by creative photographers across a wide range of disciplines – including Press, Fine Art, PR, Stock, Editorial, Reportage and Celebrity.

Magazines and newspapers in particular are voracious consumers of people pictures, and though some are sourced through picture agencies, many are specially commissioned. With many photographers chasing glamorous, lucrative and interesting work of this kind, there is strong competition, and your book needs to be bursting with the right sort of images to convince prospective clients you have what it takes. It's a Catch-22 situation: you won't get the jobs without the pictures, but how do you get the pictures if you're not getting the jobs? One way is to approach well-known faces and ask them if

they'd mind letting you take some pictures. Look them up in directories such as Who's Who and write to them. Maybe only one in ten will say yes, but if you approach enough you'll be able to make a start. It's also a good idea to watch out for famous people who are visiting your neighbourhood, perhaps to sign books or to appear in a show. They may be willing to spare you a few minutes of their time, which will enable you to add another picture or two to your portfolio.

One area in which some portrait professionals make a good living is in photographing actors, models, dancers and the like, all of whom need attractive images for their promotional cards. A range of pictures is usually required, from simple headshots to more imaginative treatments – so it's an ideal way of trying out new ideas and stretching yourself. Stock photography is an increasingly

important source of people images, and picture libraries are crying out for portraits of all kinds – from straightforward studies to more conceptual images. Subjects of every age, sex, culture and lifestyle are required, and if you're starting out you may have friends or family who will be willing to pose. Once you get established and your pictures start to sell, you can invest your earnings in hiring professional models to build up your stock of photographs further. This in time will generate yet more income.

7

Then there's the corporate world. People tend to figure strongly in annual reports and in-house publications these days, and pictures of everyone from the CEO down are required on a regular basis. Contacting businesses in your area can pay real dividends, and you may find it possible to specialise in this kind of work. Many professional photographers, though, prefer to tackle a wide range of subjects – they find it more interesting that way. But people figure in many of the pictures that are commissioned, and it's important to keep up with trends in posing and lighting in order to avoid your work looking dated – and that's where this book comes in.

style and approach

While formal portraiture still has its place, the style these days is more relaxed and informal. You see it everywhere: in magazines, in advertisements, in business communications. Gone are the stiff and starchy poses and frozen smiles that used to be so common. In their place is a softer, more natural approach that gives the pictures a more realistic sense.

How do you get someone to relax when you've probably never met them before, have only ten minutes to take the shot, and they don't like being photographed anyway? The answer is to build up a rapport. Talk to them about their life, their job, their family, their interests. Get them chatting so their focus of attention is on the interaction between you, and not the photography. Whenever possible, have a clear idea about how you want to take the pictures and get on with it efficiently and smoothly. There's nothing more unnerving for a subject than a photographer who doesn't seem to know what they're doing. Learn to work fast. People – especially celebrities – don't have time for long sessions. Be able to get in, get your shot, and get out in under five minutes.

lighting matters

If you don't have much time then sophisticated lighting set-ups are obviously out – which is one of the reasons so many of the pictures in this book were taken using only one or two heads. Setting up a single umbrella or softbox is a relatively quick procedure. Once you've used it a couple of times and if you maintain the same distance, you may not even need to take a meter reading, since the camera settings will be in mind already.

Keeping it simple has another advantage. The results look clean and contemporary. Styles change, and pictures date. You need only glance at a picture featuring a hair light, for instance, to see immediately that it's old-fashioned.

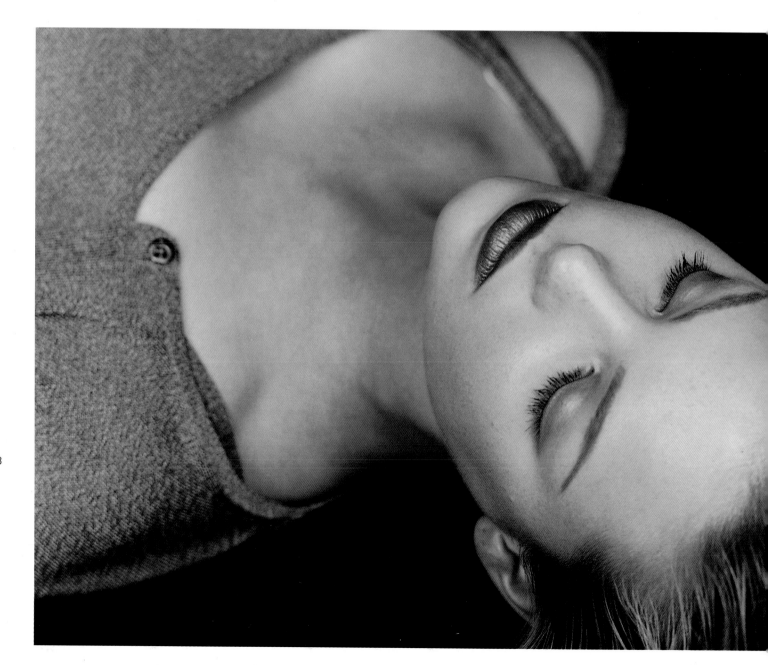

Another reason for a simple approach is that one light is also surprisingly versatile, depending upon where you place it in relation to the subject, and whether or not you add a reflector to soften the shadows. With two lights you have more control over ratios, but also the risk of overlighting the subject. Tried-and-tested set-ups include one above the camera and one below for 'beauty' lighting, and either side of the camera at 45 degrees for even coverage. Naturally there will be times when you want to use more than two lights, but think carefully about what each light is contributing to the finished picture. If it adds nothing, don't use it.

Sometimes, though, you don't need to add any additional lighting at all because the ambient illumination is perfect. Both indoor and outdoor daylight have many moods, and with a bit of help from a poly board, they can give you a quality that's hard to reproduce artificially.

equipment considerations

Depending on usage, anything goes with portrait photography. In practice, the majority of people pictures are taken using medium-format equipment because of the combination of quality, economy and convenience that it gives. 35mm is often the medium of choice for reportage work or where unobtrusive handling is the order of the day. View cameras are normally only employed where the image is to be used on a large scale or movements are required to introduce distortion.

... for portrait photography

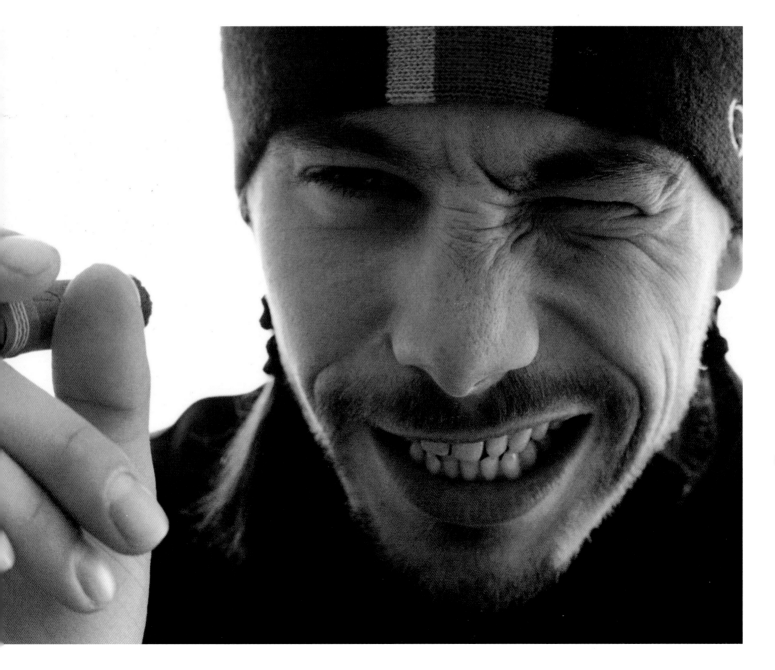

styling for portraits

What exactly does a stylist do?

The stylist's role has changed over the last five to ten years, especially in fashion photography. Traditionally they were clothes stylists, there to say what was worn and how, checking the clothes were clean and correctly put on and that they suited the subject. The stylist would also be in charge of the photograph's context, considering the background, and the props to be involved. Today, because of the trend for natural-looking imagery, the overall 'look' of the image – its total cohesion of approach – is of paramount importance. Thus the role of the stylist in being the 'eyes' of the end-user (those who the image is directed at) is much more important. In magazine portraiture and fashion photography, the stylist is now credited along with the photographer, often being given equal status. The stylist will often spend a day or two of 'prep', sourcing the clothes and considering the style of the finished image. The brief would be given by the client (the person/company paying for the photograph) or sometimes the photographer, but this is often vague (e.g. 'modern, urban and classy', or 'industrial grunge') and it would be up to the stylist to interpret that more specifically, briefing the make-up and hair stylist also. The stylist is always there throughout the shoot, checking the look – from overall approach to the details of how a collar might turn up, or a scarf might be tied – and the view of the background.

Is it possible to get one stylist who can do everything?

It's rare. Stylists tend to specialise in one area – hair, make-up or clothes – although it's increasingly common to have one person doing both the hair and the make-up. This can work better when there's limited time and can save money on airfares and hotels when shooting on location. The closest you get to someone who does all three is an Art Director, who oversees all creative areas of a shoot, and who would have a definite view of what look they want. They will think about the whole picture – the context, the room set, the clothes – and arrange things using their awareness of style intricacies. The hair stylist, make-up artist and clothes stylist work very much as a team – for example, if the model's wearing a polo-neck the stylist will ensure it's removed before large rollers go into the hair.

What can a make-up artist bring to a shoot?

It's often the make-up artist who is most aware of the lighting, since make-up products can melt under strong lights and constantly need checking. They will have expertise and experience of what make-up works best with various lighting set-ups, and they are able to create a different mood or look simply by changing the make-up.

What can a hair stylist contribute to a shoot?

The hair stylist is often simply briefed on the day. They will normally bring a large selection of hair-styling tools with them, everything from straighteners, tongs, rollers and brushes to gels and spray to wigs and hairpieces etc. This enables them to completely transform the appearance of the hair, and to make changes during the course of the shoot. Many celebrities prefer to bring along their own hair stylists.

What can a clothes stylist bring to a shoot?

Sometimes people will be photographed wearing their own clothes, and the services of a specialist clothes stylist will not be required. Where the intention is to create a certain look, it's essential to have someone who is up to date with fashion and who knows how to make clothes look good. Clothes stylists have contacts with fashion labels and can get clothes from their press contacts before they're in the shops. If the clothes are not going to have a credit – as is sometimes the case in portraiture – then the stylist will require a budget on top of the fee. The stylist will facilitate relationships with celebrities and fashion houses, who see the arrangement as mutually beneficial and will often encourage one celebrity to become associated with the label.

To what degree can a stylist create a look, an image?

Portraits often don't want to be high fashion and a stylist will be able to create a modern, yet classic look. They provide general grooming and checking (who else will notice if a vest is inside out?).

What skills will a good stylist have?

A good stylist should be able to address every job individually and work with the photographer and client to create something they are happy with, without imposing themselves or their ideas. Sometimes a stylist can push a view on a person to the extent that they no longer retain a sense of self and as a result feel they can't carry the look off because it's not them. A stylist has to step back and look at the person and not let their own personal style interfere with the job in hand. It's about working with people to create the best ultimately for that person – so they need to be versatile. Their communication skills will be excellent. They will be able to convince people they look good, which helps them relax – making life easier for the photographer.

How do you go about finding a good stylist?

Stylists can be found at agencies that represent hair and make-up, and often get known through word of mouth. There are also directories such as Fashion Monitor (UK), Le Book and Diary Directory (UK), which list photographers, venues, agencies and labels as well as stylists. It's also worth tracking down stylists who want to test. Some are willing to offer their services free initially in exchange for prints with which they can build a portfolio of their work.

On what basis do stylists charge?

It depends on the experience of the stylist and the agent. They charge by the day and typically cost from £350 to £2000, depending on the job and who the stylist is. Clothes stylists will also charge half that fee for the prep day (when they source the clothes).

making light work

understanding, measuring and using light to create exciting and memorable images

Light is the single most important element in any picture. You try taking a picture without any! And it's the way you use light that often makes the difference between success and failure. You can have the most attractive or interesting subject in the world, get your exposure right and focus perfectly, but if the lighting's not good you can forget it. However, it's astonishing how few photographers pay any real attention to light. Even professionals can be so eager to press the shutter release and get the shot in the bag – they don't really think about how to make the light work for them. Getting to know light, and being able to use it creatively, are essential skills for any photographer. One of the best ways of developing and deepening that understanding is to monitor the many moods of daylight. You might find yourself noticing how beautiful the light is on the shady side of a building, or coming in through a small window, or dappled by the foliage of a tree – and store that awareness and knowledge away for use when planning a shoot in the future. The most amazing thing about light is its sheer diversity – sometimes harsh, sometimes soft; sometimes neutral, sometimes rosy or blue; sometimes plentiful, sometimes in short supply.

more doesn't mean better

Taking pictures is easy when there's lots of light. You're free to choose whatever combination of shutter speed and aperture you like without having to worry about camera-shake or subject movement – and you can always reduce it with a Neutral Density filter if there's too much.

But don't confuse quantity with quality. The blinding light you find outdoors at noon on a sunny day or bursting out of a bare studio head may be intense, but it's far from ideal for most kinds of photography. More evocative results are generally achieved when the light is modified in some way, with overall levels often much lower. With daylight, this might be by means of time of day – early morning and late evening being more atmospheric, or by weather conditions, with clouds or even rain or fog producing very different effects. Some of the most dramatic lighting occurs when opposing forces come together – such as a shaft of sunlight breaking through heavy cloud after a storm. In the studio, as well as the number of lights used and their position, it's the accessories you fit which determine the overall quality of the light.

controlling the contrast

For some situations and subjects you will want light that is hard and contrasty, with strong, distinct shadows and crisp, sharp highlights. Outdoors when it's sunny, the shadows are darker and shorter around noon, and softer and longer when it's earlier and later in the day. Contrasty lighting can result in strong, vivid images with rich, saturated tones if colour film has been used. However, the long tonal range you get in such conditions can be difficult to capture on film. Care must be taken when doing so that no important detail is lost or that the image doesn't then look either too washed out or too heavy. If so, some reduction in contrast can often be achieved by using reflectors.

This kind of contrasty treatment is not always appropriate or suitable, however, and for many subjects and situations a light with a more limited tonal range that gives softer results may work better. Where you want to show the maximum amount of detail, or create a mood of lightness and airiness, with the minimum of shadows, the soft lighting of an overcast day or a large softbox is unbeatable. The degree of contrast also depends upon the direction from which the light is coming. In every picture you are using light to reveal something about the subject – its texture, form, shape, weight, colour or even translucency. So look carefully at what you are going to photograph, and consider what you want to convey about it, then start to organise the illumination accordingly.

light isn't white

We generally think of light as being neutral or white, but in fact it varies considerably in colour. You need only think about the orange of a sunrise or the blue in the sky just before night sets in. The colour of light is measured in what are known as Kelvins (K), and the range of possible light colours makes up what is known as the Kelvin scale. Standard daylight-balanced film is designed to be used in noon sunlight, which typically has a temperature of 5500°K. Electronic flash is the same. However, if you use daylight film in light of a lower colour temperature you'll get a warm, orange colour, while if you use it in light of a higher temperature, you'll get a cool, blue tonality. Such casts are generally regarded as wrong, but if used intentionally they can give a shot more character than the blandness of a clean white light.

daylight moods

One option for certain kinds of work is to run your studio on daylight – and some professionals do just that. Consider the advantages: the light you get is completely natural, unlike flash you can see exactly what you're getting, and it costs nothing to buy or run. When working outdoors, light can be controlled by means of large white and black boards which can be built around the subject to produce the effect required. Indoors, you might want to choose a room with north-facing windows, because no sun ever enters and the light remains constant throughout the day. However, this may be a little cool for colour work, giving your shots a bluish cast. If so, simply fit a pale orange colour-correction filter over the lens to warm things up – an 81A or 81B should do fine. Rooms facing other points of the compass will see changes of light colour, intensity and contrast throughout a day. When the sun shines in you'll get plenty of warm-toned light that will cast distinct shadows. With no sun, light levels will be lower, shadows softer, and colour temperature more neutral.

The room's windows also determine how harsh or diffuse the light will be. Having a room with at least one big window, such as a patio door, will make available a soft and even light. The effective size of the window can easily be reduced for a sharper, more focused light, by means of curtains or black card. In the same vein, light from small windows can be softened with net curtains or tracing paper. The ideal room would also feature a skylight, adding a soft, downwards light.

Whatever subject you're shooting, you'll need a number of reflectors to help you make the most of your daylight studio – allowing you to bounce the light around and fill in shadow areas to contrast.

studio control

Daylight studios are great, but they have obvious disadvantages: you can't use them when it's dark; you can't turn the power up when you need more light; and you don't have anywhere near the same degree of control you get when using studio heads. Being able to place lights exactly where you want them, reduce or increase their output at will, and modify the quality of the illumination according to your needs means the only limitation is your imagination.

making light work

...continued

Some photographers seem to operate on the basis of 'the more lights the better', using their every light all the time. But there's a lot to be said for simplicity, and some of the best photographs are taken using just one perfectly positioned head. By using different modifying accessories with the head, you can alter the quality of its output according to your photographic needs. Before going on to more advanced set-ups, it pays to learn to make the most of just a single light source – trying it in different positions and at different heights. If you want to soften the light further and give the effect of having a second light of lower power, a simple white reflector is all you need.

Of course, having a second head does give you many more options – as well as using it for fill-in you can place it alongside the main light, put it over the top of the subject, or wherever works well. Having two lights means you can also control the ratio between them, reducing or increasing their relative power to control the contrast in the picture. For many subjects a lighting ratio of 1:4 (one light has 1/4 of the power of the other) is ideal, but there are no hard-and-fast rules.

In practice, many photographers will need to have at least three or four heads in their armoury, and unless advanced set-ups are required or enormous firepower, that should be sufficient for most situations. However, it is worth reiterating that it is all too easy to overlight a subject, with unnatural and distracting shadows going in every direction. So before you introduce another light, try asking yourself what exactly it adds to the image – and if it adds nothing, don't use it.

tungsten or flash?

This is the main choice when buying studio heads, and both have pros and cons. Tungsten units tend to be cheaper and have the advantage of running continuously, allowing you to see exactly how the light will fall in the finished picture. However, the light has a strong orange content, typically around 3400°K, requiring the use of tungsten film or a blue correction filter for a neutral result. Tungsten lights can also generate enormous heat, making them unsuitable for certain subjects. Flash heads are more commonly used because they are much cooler to run, produce a white light balanced to standard film stocks, and have a greater light output. Many studios have both types, and a decision about which to use is based on the requirements of the job in hand.

accessories that assist

Every bit as important as the lights themselves are the accessories you fit on them. Few pictures are taken with just the bare head as the light goes everywhere, which is not what you want. To make the light more directional you can fit a dish reflector, which narrows the beam and allows you to restrict it to certain parts of your subject. A more versatile option is provided by barn doors, which have four adjustable black flaps that can be opened out to accurately control the spill of the light. If you just want a narrow beam of light, try fitting a snoot – a conical black accessory which tapers to a concentrated circle.

Other useful accessories include spots and fresnels, which you can use to focus the light, and scrims and diffusers to reduce the harshness. If you want softer illumination, the light from a dish reflector can be bounced off a large white board or, more conveniently and especially for location work, fired into a special umbrella. If that's not soft enough for you, invest in a softbox – a large white accessory that mimics windowlight and is perfect for a wide range of subjects. The bigger the softbox, the more diffuse the light.

measuring light

Over recent years the accuracy of in-camera meters has advanced enormously. By taking separate readings from several parts of the subject, and analysing them against data drawn from hundreds of different photographic situations, they deliver a high percentage of successful pictures. However, the principal problem with any kind of built-in meter remains the fact that it measures the light reflected back from the subject – so no matter how sophisticated it may be, it will be prone to problems in tricky lighting situations, such as severe backlighting or strong sidelighting.

An additional complication is that integral meters don't know what you're trying to do creatively. So, while you might prefer to give a little more exposure so that the shadows have plenty of detail when working with a black & white negative, or to reduce exposure by a fraction to boost saturation when shooting colour slides, your camera's meter will come up with a 'correct' reading that produces bland results.

For all these reasons, any self-respecting professional photographer or serious amateur will invest in a separate lightmeter, which will give them full control over the exposure process – and 100 per cent accuracy. Hand-held meters provide you with the opportunity to do something your integral meter never could – take an 'incident' reading of the light falling onto the subject. With a white 'invercone' dome fitted over the sensor, all the light illuminating the scene is integrated, avoiding any difficulties caused by bright or dark areas in the picture. When using filters, you can either take the reading first and then adjust the exposure by the filter factor if you know it, or the filter over the sensor when making a measurement.

Those seeking unparalleled control over exposure should consider buying a spot meter, which allows you to take a reading from just 1 per cent of the picture area. Most have a viewfinder you look through when measuring exposure. At the centre is a small circle, which indicates the area from which the reading is made.

Many of the more expensive hand-held meters, both incident and spot, have a facility for measuring electronic flash as well. For those who don't feel the need for an ambient meter, separate flash-only meters are available. The benefit of having a meter that can measure flash is obvious. In the studio it allows you to make changes to the position and power of lights and then quickly check the exposure required. When using a portable electronic gun, you can use it to calculate the amount of flash required to give a balanced fill-in effect.

Incident flash meters are used in exactly the same way as when taking an ambient reading. The meter is placed in front of the subject, facing the camera, and the flash fired. This can usually be done from the meter itself by connecting it to the sync cable, and pressing a button. Another useful feature that's widely available allows you to compare flash and ambient readings – perfect if you're balancing flash with ambient light or want to mix it with tungsten. Some of the more advanced flash meters can also total multiple flashes – ideal if you need to fire a head several times to get a small aperture for maximum depth of field.

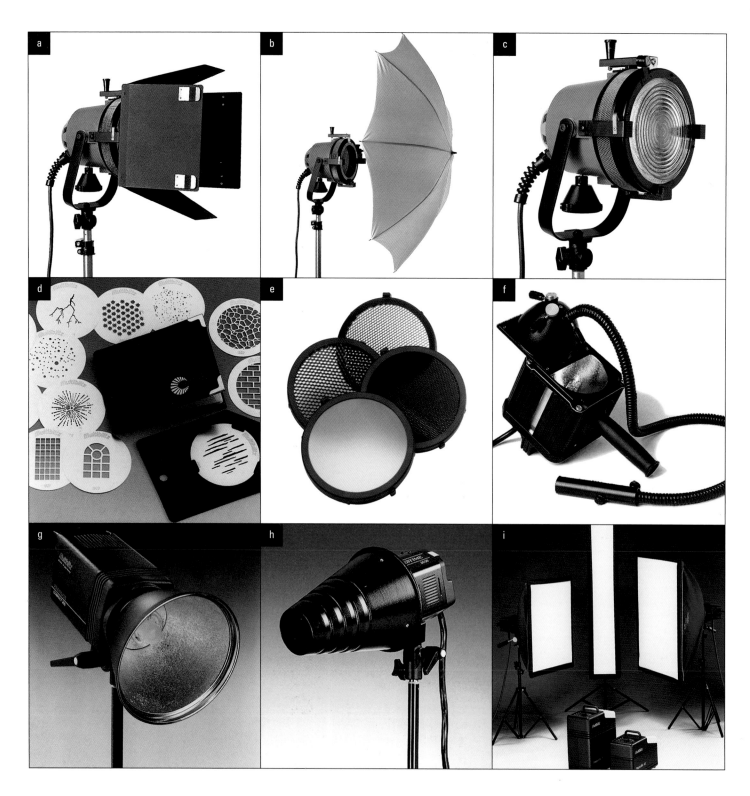

glossary of lighting terms

Acetate
Clear plastic-like sheet often colour-tinted and fitted over lights for a colour cast

Ambient light
Naturally occurring light

Available light
See Ambient light

Back-projection
System in which a transparency is projected onto a translucent screen to create a backdrop

Barn doors (a)
Set of four flaps that fit over the front of a light and can be adjusted to control the spill of the light

Boom
Long arm fitted with a counterweight which allows heads to be positioned above the subject

Brolly (b)
See Umbrella

CC filters
Colour correction filters used for correcting any imbalance between films and light sources

Continuous lighting
Sources that are 'always on', in contrast to flash which only fires briefly

Cross-processing
The use of unconventional processing techniques, such as developing colour film using black & white chemistry

Diffuser
Any kind of accessory which softens the output from a light

Effects light
Light used to illuminate a particular part of the subject

Fill light
Light or reflector designed to reduce shadows

Fish fryer
Extremely large softbox

Flash head
Studio lighting unit which emits a brief and powerful burst of daylight-balanced light

Flag
Sheet of black card used to prevent light falling on parts of the scene or entering the lens and causing flare

Fluorescent light
Continuous light source which often produces a green cast with daylight-balanced film – though neutral tubes are also available

Fresnel (c)
Lens fitted to the front of tungsten lighting units which allows them to be focused

Giraffe
Alternative name for a boom

Gobo (d)
Sheet of metal or card with areas cut out, designed to cast shadows when fitted over a light

HMI
Continuous light source running cooler than tungsten but balanced to daylight and suitable for use with digital cameras

Honeycomb (e)
Grid that fits over a lighting head producing illumination that is harsher and more directional

Incident reading
Exposure reading of the light falling onto the subject

Joule
Measure of the output of flash units, equivalent to one watt-second

Kelvin
Scale used for measuring the colour of light. Daylight and electronic flash are balanced to 5500°K

glossary of lighting terms

...continued

Key light
The main light source

Kill spill
Large flat board designed to prevent light spillage

Lightbrush (f)
Sophisticated flash lighting unit fitted with a fibre-optic tube that allows the photographer to paint with light

Light tent
Special lighting set-up designed to avoid reflections on shiny subjects

Mirror
Cheap but invaluable accessory that allows light to be reflected accurately to create specific highlights

Mixed lighting
Combination of different coloured light sources, such as flash, tungsten or fluorescent

Modelling light
Tungsten lamp on a flash head which gives an indication of where the illumination will fall

Monobloc
Self-contained flash head that plugs directly into the mains (unlike flash units, which run from a power pack)

Multiple flash
Firing a flash head several times to give the amount of light required

Perspex
Acrylic sheeting used to soften light and as a background

Ratio
Difference in the amount of light produced by different sources in a set-up

Reflector
1) Metal shade around a light source to control and direct it (g)
2) White or silvered surface used to bounce light around

Ringflash
Circular flash tube which fits around the lens and produces a characteristic shadowless lighting

Scrim
Any kind of material placed in front of a light to reduce its intensity

Slave
Light-sensitive cell which synchronises the firing of two or more flash units

Snoot (h)
Black cone which tapers to concentrate the light into a circular beam

Softbox (i)
Popular lighting accessory producing extremely soft light. Various sizes and shapes are available – the larger they are, the more diffuse the light

Spill
Light not falling on the subject

Spot
A directional light source

Spot meter
Meter capable of reading from a small area of the subject – typically 1–3 degrees

Stand
Support for lighting equipment (and also cameras)

Swimming pool
Large softbox giving extremely soft lighting (see also Fish fryer)

Tungsten
Continuous light source

Umbrella (b)
Inexpensive, versatile and portable lighting accessory. Available in white (soft), silver (harsher light), gold (for warming) and blue (for tungsten sources). The larger the umbrella, the softer the light

practicalities

How to gain the most from this book

The best tools are those which can be used in many different ways, which is why we've designed this book to be as versatile as possible. Thanks to its modular format, you can interact with it in whichever way suits your needs at any particular time. Most of the material is organised into self-contained double-page spreads based around one or more images – though there are also some four- and six-page features that look at the work of a particular photographer in more depth. In each case there are at least two diagrams which show the lighting used – based on information supplied by the photographer. Copy the arrangement if you want to produce a shot that's similar. Naturally the diagrams should only be taken as a guide, as it is impossible to accurately represent the enormous variety of heads, dishes, softboxes, reflectors and so on that are available, while using an accessible range of diagrams, nor is it possible to fully indicate lighting ratios and other such specifics. In practice, however, differences in equipment, and sometimes scale, should be small, and will anyhow allow you to add your own personal stamp to the arrangement you're seeking to replicate. In addition you'll find technical details about the use of camera, film, exposure, lens etc. along with any useful hints and tips.

icon key

- Photographer
- Client
- Possible uses
- Camera
- Lens
- Film
- Exposure
- Type of light

understanding the lighting diagrams

three-dimensional diagrams

large-format camera

medium-format camera with portable flash

medium-format camera

35mm camera

standard head

standard head with barn doors

spot

spot with honeycomb

spot with snoot

softbox

diffuser

strip light

reflector

backdrop

plan view diagrams

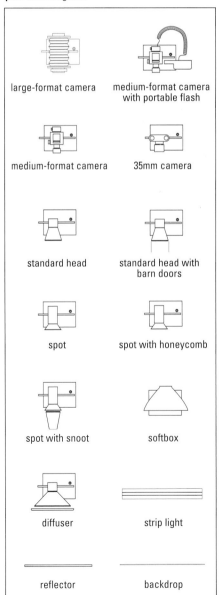

large-format camera

medium-format camera with portable flash

medium-format camera

35mm camera

standard head

standard head with barn doors

spot

spot with honeycomb

spot with snoot

softbox

diffuser

strip light

reflector

backdrop

19

outdoor / ambient

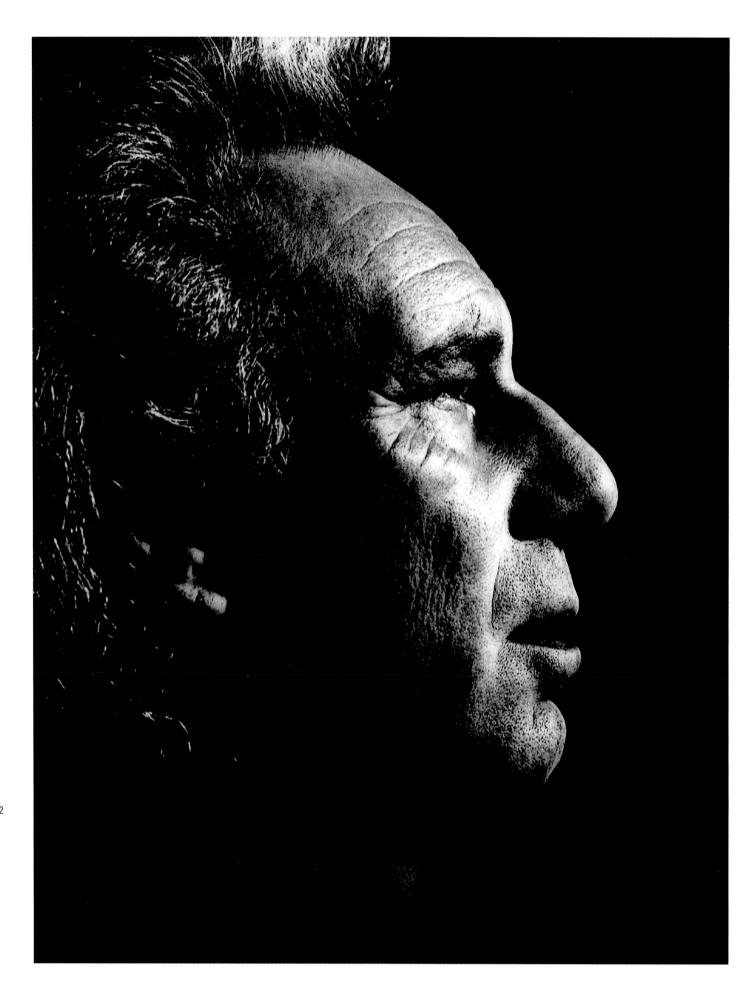

One of the most powerful ways of photographing someone with strong features is to shoot them in profile – and this picture shows how effective the approach can be when done well.

By asking his subject to face a window, and by positioning him in front of a black door, the photographer has defined the outline of the face perfectly by means of the slight backlighting. The window has clear, unbroken light falling onto the face, and the door provides a background too dark to register. The effect has been further enhanced by printing the image on a contrasty paper. Any residual background detail has burnt in, and it has been given a final boost digitally.

(†) Fin Costello
(⊚) El Pais newspaper, Spain
(◉) Editorial
(▥) 35mm
(◍) 50mm
(▣) Kodak Plus-X
(◷) 1/250sec at f/5.6
(◉) Window light

plan view

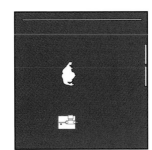

strong profile

23

Hard printing helps make the best of a super profile shot.

It's hard to create soft, delicate and flattering light like this in the studio – and, yes, this picture was taken using daylight. The actress Angelina Jolie is standing just inside a doorway, with a black paper background behind her. Standing outside is photographer Jeff Dunas, with two 4 x 8ft white panels and a white wall about 12ft behind him reflecting sunlight back at the subject.

'When you're photographing a celebrity wearing glasses and you don't have much time, you've got to be careful with flash,' Dunas warns. 'There's always a chance you're going to get reflections you're not aware of. With daylight you can concentrate on the subject without having to worry about things like that.'

Ⓐ Jeff Dunas
Ⓑ Max magazine, USA
Ⓒ Various
Ⓓ 6 x 7cm
Ⓔ 150mm
Ⓕ Agfachrome 100
Ⓖ 1/125sec at f/4
Ⓗ Electronic flash and daylight

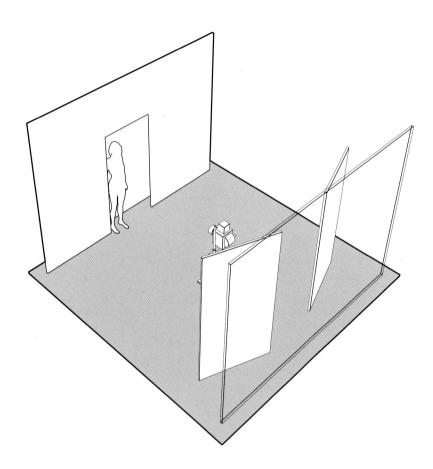

creating meaningful images

'What I'm looking to do is have something very meaningful and very important with the subject that creates the content of the picture,' reveals Dunas. 'Sometimes I'm given just five minutes with a person, and I need to make an instant connection with them. My tendency is to work for a short but intense period of time where I'm focused like a laser on getting what I want. You need to make that subject reveal something of themselves to you. It's a brief thing, and it all happens in a moment.'

plan view

angelina jolie

24

Placing your subject facing out of a doorway gives soft illumination.

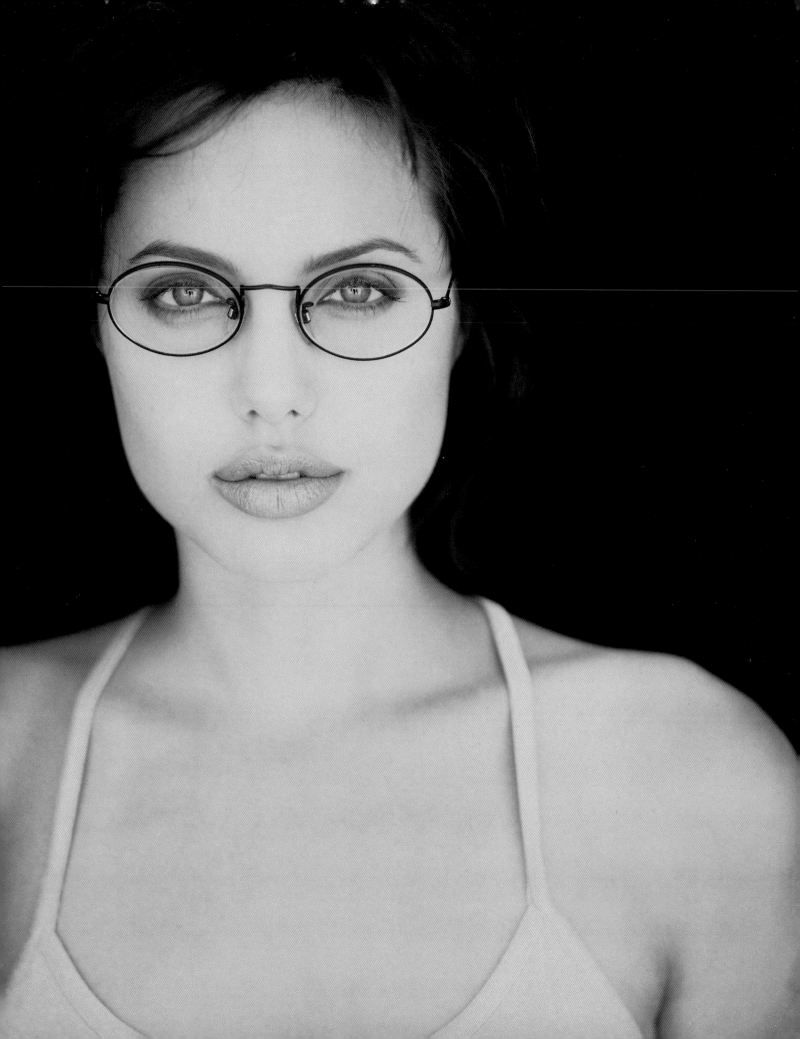

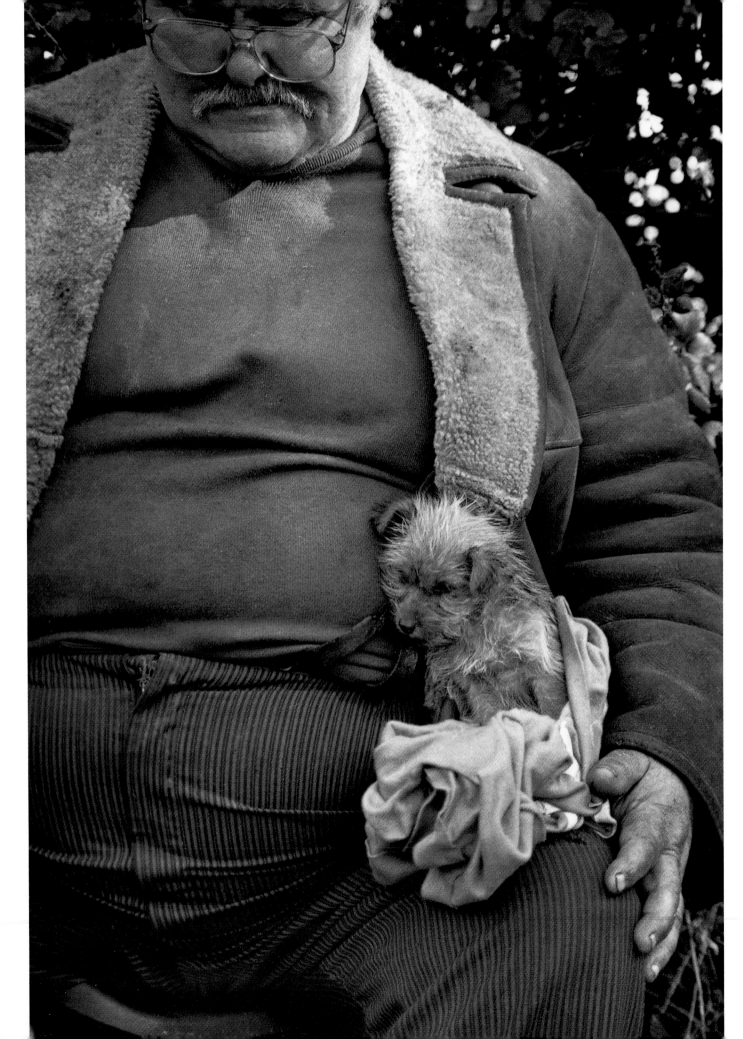

As part of a project on the Gypsy community in Britain, Jo McGuire travelled around capturing reportage-style portraits of some of the leading characters. Shooting hand-held with 35mm equipment and using a fast emulsion, she sought to record them in as natural and honest a way as possible. This meant working entirely with daylight, and making the most of its many moods to produce a lasting testimony to the rapidly changing way of life. The two pictures here are typical of her style.

The picture of Ezzi Taylor with his dog is wonderfully evocative, thanks in no small part to the late afternoon light raking across from behind. Under normal circumstances this might have been too harsh, but happily a camp fire was burning just in front of the photographer, and the flickering flames balanced the lighting perfectly.

(人) Jo McGuire
(↻) Personal project
(◉) Exhibition
(▦) 35mm
(◕) 85mm
(▣) Kodak T-Max 400
(◷) 1/125sec at f/5.6
(◉) Ambient light and firelight

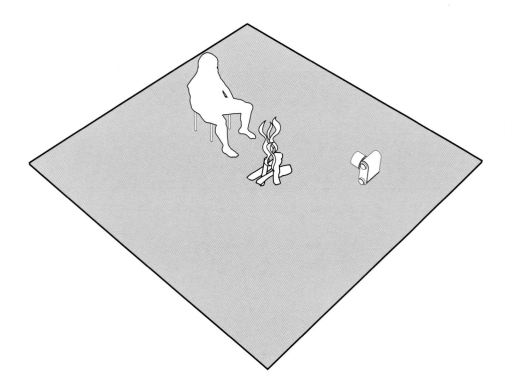

plan view

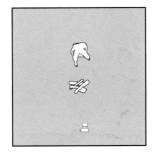

gypsy kings

Careful choice of ambient lighting conditions contributes to the overall feel of the picture.

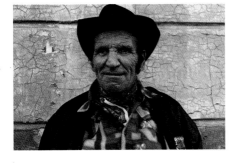

Kevin Price has been shot standing in front of a cracked wall on Brick Lane in London, which seems to echo the lines on his face. The soft light of an overcast day produces flat and sympathetic illumination, while the white canopy of a stand behind the photographer acts as a natural reflector to lighten the face and put a catchlight in the eye.

'The light was dreadful,' says Llewellyn Robins of the time he came to take this picture. 'It was a flat, grey, overcast day, with no hint of sun whatsoever.'

However, knowing that a problem is really only an opportunity in disguise, he decided to create his favoured kind of lighting by taking his subject on location to a barn. Placing him 2m inside the barn, the light coming in was wonderfully directional – like having an enormous softbox whose size can be controlled by how far open the doors are. The resulting illumination is deliciously soft and frontal, and it also reveals the texture of the graphite, metal and glass sculpture the man is holding. Careful printing was required to darken down the edges and extract every last drop of quality from the picture.

Llewellyn Robins
Private commission
Publicity
6 x 6cm
80mm
Kodak T-Max 400
1/4sec at f/4
Ambient light

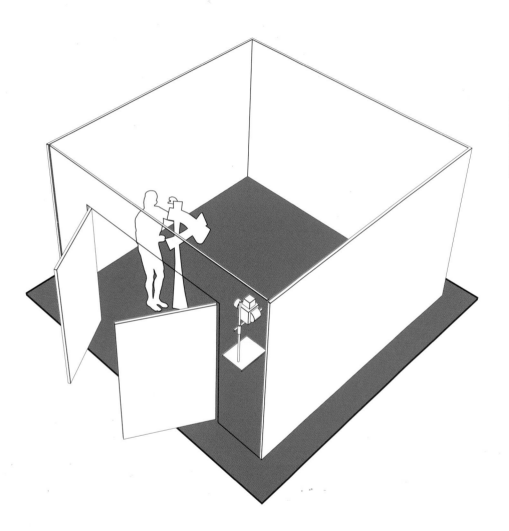

plan view

28 man with sculpture

Finding some way of creating directional lighting on an overcast day produces a softer, more attractive result.

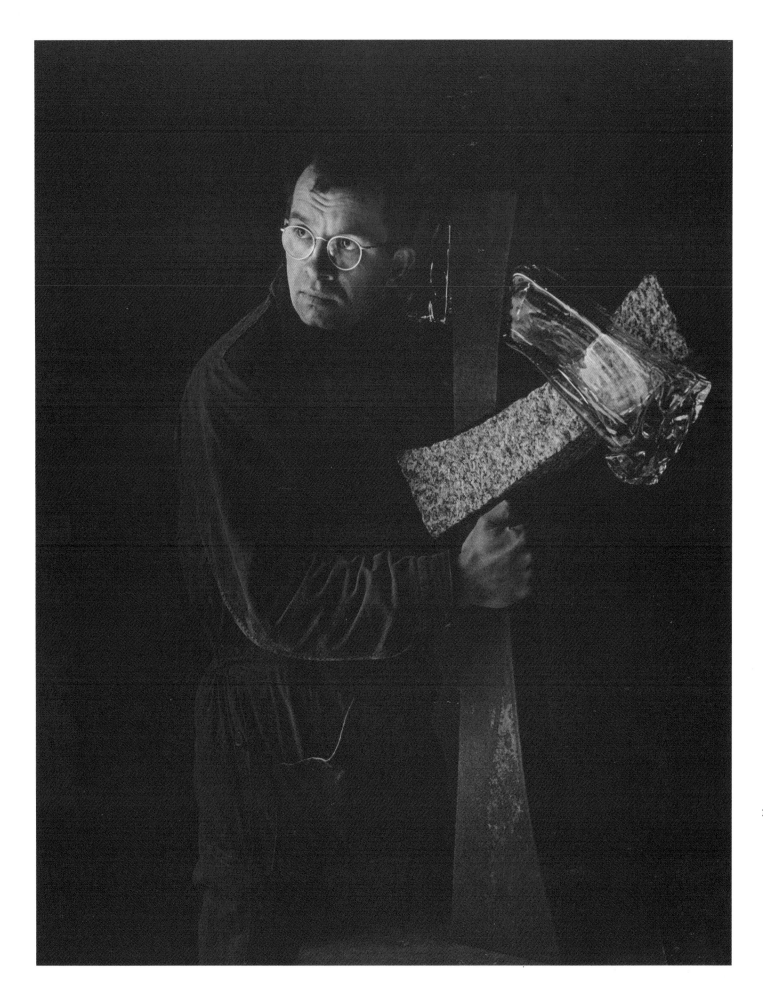

a palette of light

Focusing on the works of Linda Troeller

While many photographers favour studio lighting for the precision and control it gives them, others prefer the more natural and realistic pictures you get with ambient light. One photographer who works almost entirely with the light that's already there is Linda Troeller. The pictures here, taken from her book The Erotic Lives of Women, are typical of her approach; which developed in the course of a project documenting healing waters and spas. 'The lighting was strange at many of the places I had to photograph,' she says, 'for example there was infrared and fluorescent. The locations were often also rather dark, and as a result I started to use a much faster-speed film. Sometimes I would get blur because of subject movement during the long shutter speeds and this, in combination with the unusual lighting, gave me a palette which I liked, and which has been a happy part of my photography ever since.'

The Erotic Lives of Women features photographs of women in connection with the place where they had their first erotic experience – often revisiting it for their portrait. 'All of the 35 women featured in Erotic Lives chose the location where they wanted their pictures taken; this was generally their home, where they felt comfortable. I was thrown into a situation where I had to make the most of whatever was existing. I like that surprise element. For me it's a magical kind of a situation to have to come up with something. I never once brought in a flashgun or a studio head. However, I did move lamps to better positions, open windows if necessary, or switch all the lights on. I would see how I could best light the situation using what was already available.'

'Incandescent light is a terrific source for discovering movement – which gives a lot of reality to pictures. In a commercial sense the orange cast you get from tungsten room lights is a

fault, but for me it's an honest record of how things were. Commercial photographers have told me that looking at my work has helped free them from some of the responsibilities they thought they had in their photography.'

Troeller's only concession to manipulating the light is to sometimes use reflectors – she has silver, and double-sided silver and gold, and gold and white folding types. These are employed to bounce light into areas which are unacceptably dark.

Her photographs are taken using 35mm autofocus SLRs, usually hand-held but sometimes with a tripod. As you might imagine, the two zoom lenses used are often set at maximum aperture, and shutter speeds are generally in the range of 1/60sec to 4 seconds. Mostly the camera is set to a programmed exposure, so attention can be focused on the subject, leaving the camera to take care of the technicalities.

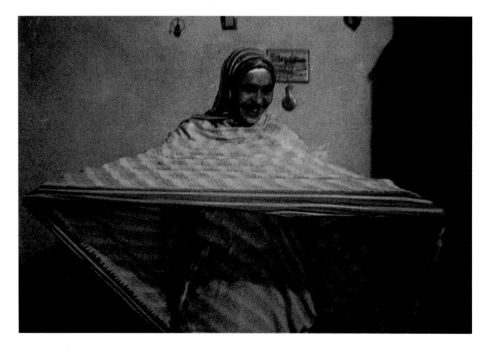

nadia

'I photographed Nadia in a small room she had near a busy square. It had no windows, and I used the bare bulb from the ceiling.'

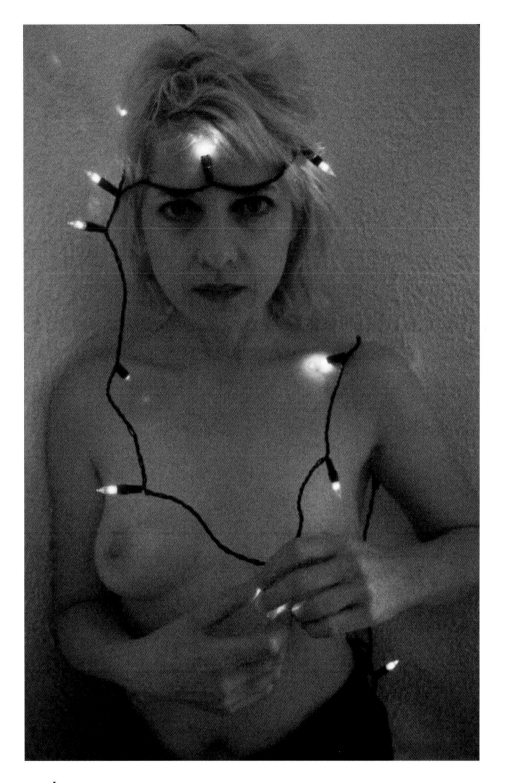

 Linda Troeller

Personal project

The Erotic Lives of Women monograph, Exhibition

35mm

35–105mm (at 80mm)

Kodachrome 200

1/15sec at f/5.6

Ambient light

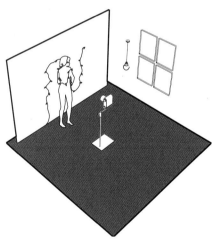

pal

'This was photographed in a third-floor room in the Chelsea Hotel in New York. I mixed window light with incandescent overhead light on the ceiling and incandescent Christmas tree lights that were throughout the room and against her skin.'

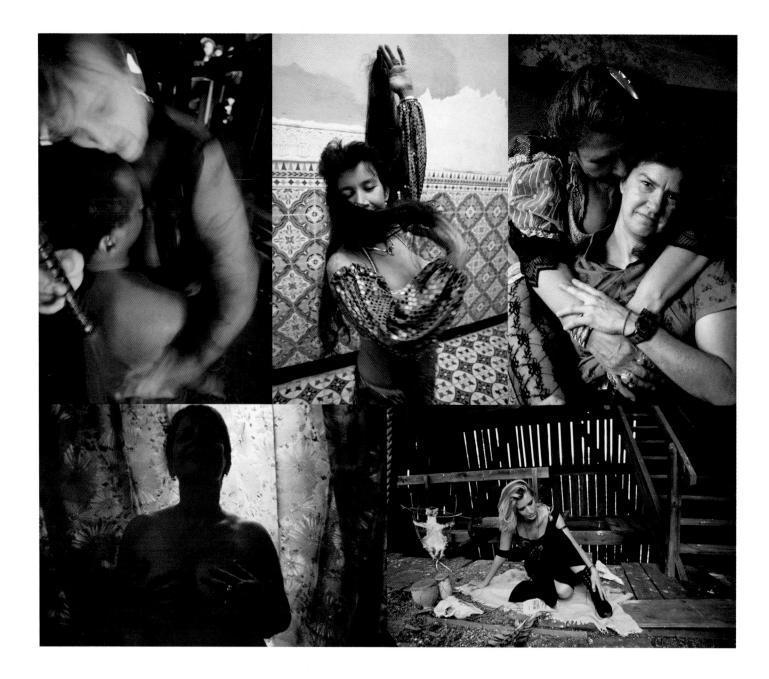

eva

'I photographed Eva in her studio, incorporating light from a small window and from a floor lamp.'

fatima

'I photographed Fatima in a courtyard. It was an overcast day with soft light falling at an angle through the hole in the roof.'

murial

'This picture was taken in natural light by a window in the Native American Institute in New York City.'

ruti

'I took these pictures of Ruti in an apartment using window light as backlighting and fluorescent light that was above the sink in the bathroom.'

andrea

'I photographed Andrea in the top of a windmill, with an open-air ceiling, natural light, and various lighting tunnels from all four directions.'

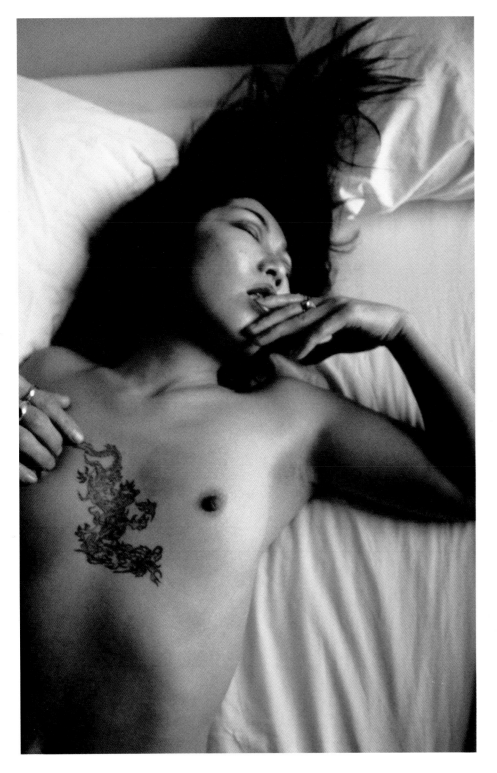

(A) Linda Troeller
(⌀) Personal project
(◉) The Erotic Lives of Women monograph, Exhibition
(▨) 35mm
(◍) 35–105mm (at 90mm)
(▥) Kodachrome 200
(◷) 1/30sec at f/5.6
(◎) Ambient light

plan view

yoko

'This photograph was taken using just the light from a window.'

33

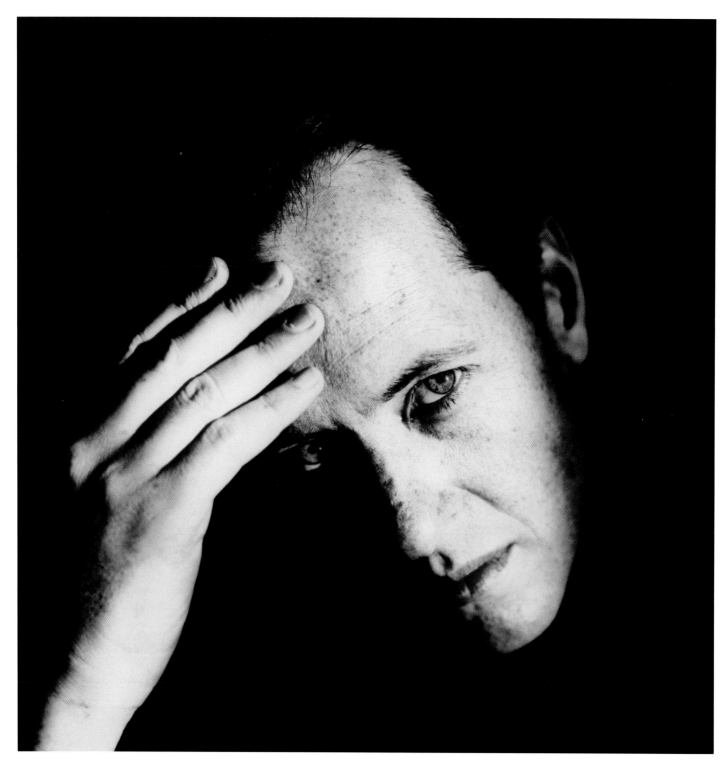

richard e grant

Late evening sun picks out the subject with a dramatic shaft of sunlight.

The blue piercing eyes peering out from a disembodied head create such drama, it looks as if the subject might have been lit by a spotlight. In a sense he was; the light is provided by a shaft of late afternoon sun which is streaming through a window to the right of and behind the photographer; this produces a gorgeous 'wraparound' effect. For this type of effect, the model must only wear black clothes.

The contrast of the shot was enhanced by cross-processing the transparency film in C41 chemistry – this process also had the advantage of losing all of the detail in the background, which might otherwise have been distracting.

Matt Moss
Personal project
Portfolio
6 x 6cm
110mm
Kodak EPP
1/125sec at f/8
Window light

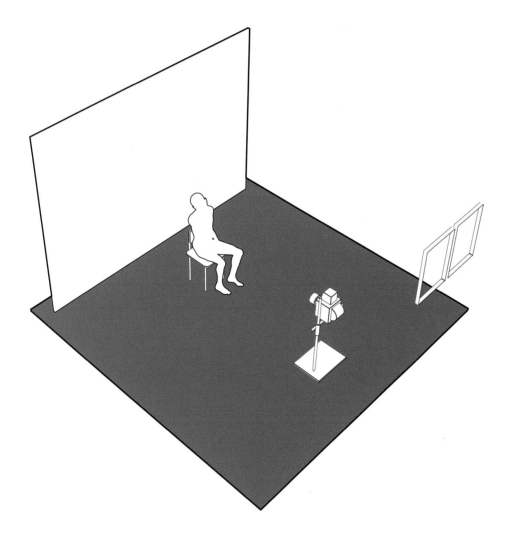

plan view

35

An overcast day such as this, with heavy toplight, would not normally be used for outdoor portraiture, as the shadows are less than flattering. However, Wie wanted an angry, severe, unhappy expression, and deliberately chose conditions which enhanced that feeling. The only addition was an improvised reflector – a double bedsheet which she hung on the right-hand side of the frame to create a little contrast. The finished image was sepia-toned to give an old-fashioned feel.

(人) Marianne Wie
(◔) Personal project
(◑) Editorial
(◉) 6 x 6cm
(◉) 80mm
(▶) Ilford Delta 100
(◷) 1/30sec at f/5.6
(◌) Overcast daylight

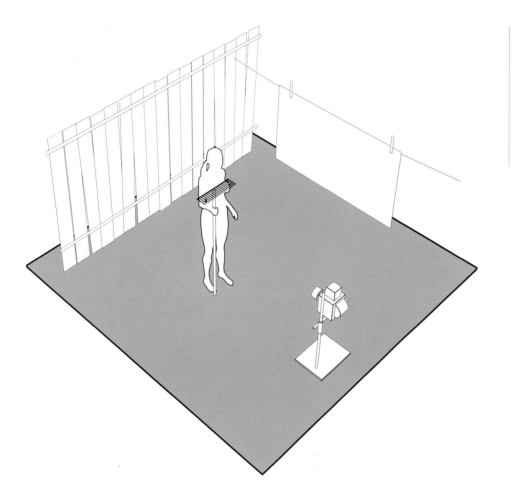

plan view

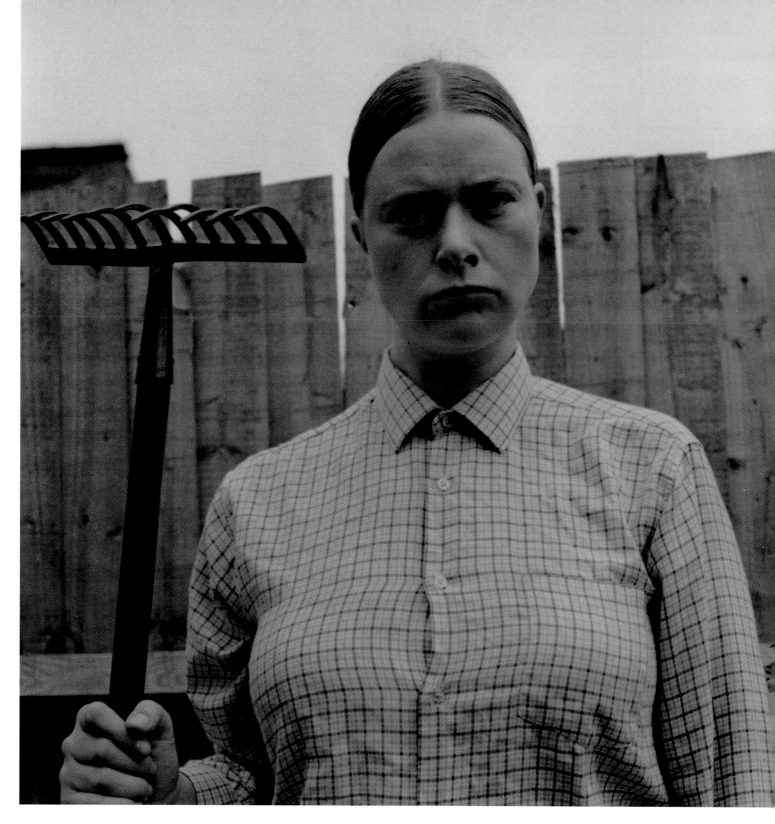

woman with rake

Drawing her inspiration from the painting 'American Gothic' by Grant Wood, Marianne Wie created this self-portrait in her back garden – setting the camera up on a tripod and getting a friend to fire the shutter for her.

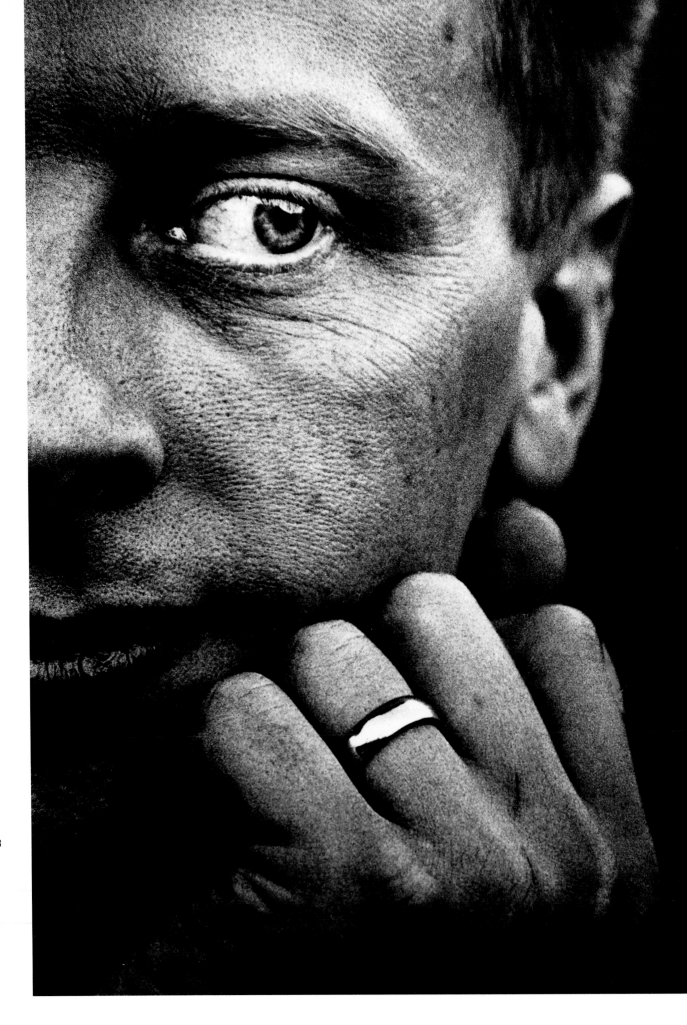

Cropping tightly into the face is always guaranteed to create an image with impact – and this shot is no exception. Your attention goes immediately to the eye, thanks in part to the graphic treatment, with the edges of the picture printed to appear really dark. Surprisingly, the picture was taken as part of the coverage of a wedding – hence the ring – further evidence of the degree to which social photography is increasingly drawing upon advertising and fashion styles.

In fact the original shot included more of the face, but the photographer decided to crop in even more tightly at the printing stage. Initially prints featured a full tonal range, but a much more 'contrasty' treatment was tried and worked well, using Grade 5 paper. The lighting could not have been more simple, with the subject standing outdoors late in the evening of an overcast day. The catchlight in the eye is the sky.

In retrospect, Harper wonders whether he should have asked the subject to look directly at the camera, rather than to the side. 'I've done similar shots where the subject is staring straight at you,' he says, 'and they seem to be more powerful. I just wanted to try something a little different.'

Nigel Harper
Private commission
35mm
28–80mm
Fuji Neopan 400
1/60sec at f/4
Ambient light

plan view

the groom

Bold cropping, limited depth of field and contrasty printing produce a literally 'eye-catching' image.

available-light press photography

Making the most of existing lighting allows press images for use in newspapers to be captured quickly and easily.

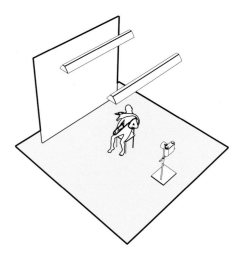

Taking pictures of people for publication in a newspaper or periodical can be a challenging business. Often you have no more than a few minutes, so there's not enough time to set up additional lighting, yet picture editors demand images with a certain amount of subtlety. Using a burst of fill-in flash from a gun attached to the camera is one way of ensuring the subject is fully illuminated – but the images all too often are flat and uninteresting as a result. The secret lies in making the most of whatever lighting already exists in the scene; and placing the subject whenever possible in literally the right light. Through developing this skill, Pauline Neild has become a sought-after contributor to national and regional newspapers in the UK.

ancient instrument

One of the best ways of concentrating attention on the most important part of the picture is to frame it. Here, Neild has used an ancient musical instrument relating to the subject to provide a frame and dramatic foreground interest. The picture was taken in a medium-sized basement and, because there was no opportunity to set up additional lighting, she had to make use of the strip lights on the ceiling. However, by positioning the subject carefully in front of an area of white wall, she was able to contrast the face effectively against the shadowed areas of the instrument. It was then simply a matter of waiting for the right expression and firing the shutter.

- Pauline Neild
- Times Educational Supplement newspaper, UK
- Press
- 35mm
- 28–105mm (at 50mm)
- Fuji Superia 400
- 1/15sec at f/4
- Ambient light

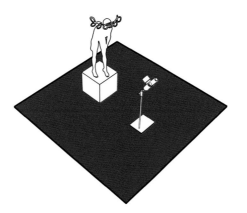

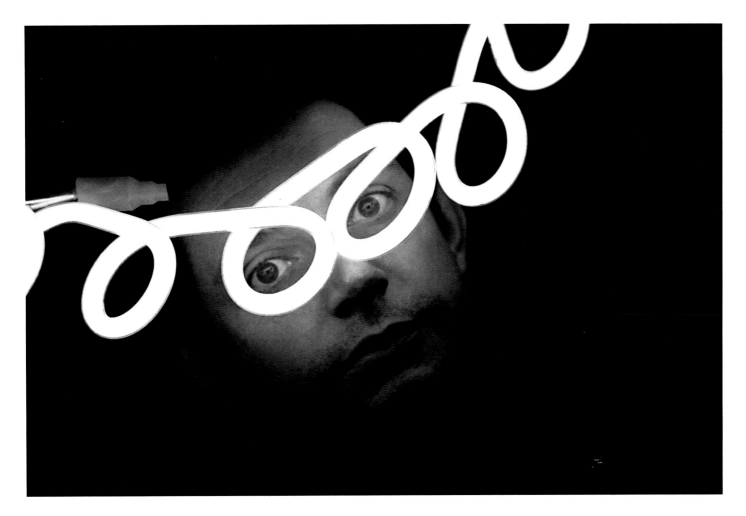

neon tubing

It's not that often that the lighting for a portrait forms an essential element in the shot – but that's what happened here. The subject is an artist who works with neon-filled lights, and Neild wanted an image that conveyed that fact in an eye-catching way. After trying out a number of ideas she noticed a curled length of neon tubing hanging from the ceiling of the gloomy workshop where she was taking the pictures. It wasn't long before she had the artist balancing on a box, peering through the circles to produce the photograph she was looking for. No other lighting was added. Metering to make sure the face was correctly exposed, she allowed the neon tube lighting to burn out, and the final print – already monochromatic – was printed in black & white.

Pauline Neild
Manchester Evening News newspaper, UK
Press
35mm
28–105mm (at 80mm)
Fuji Superia 400
1/15sec at f/4
Ambient light

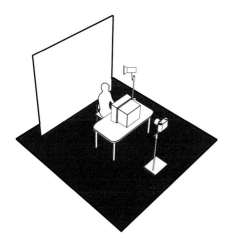

plan view

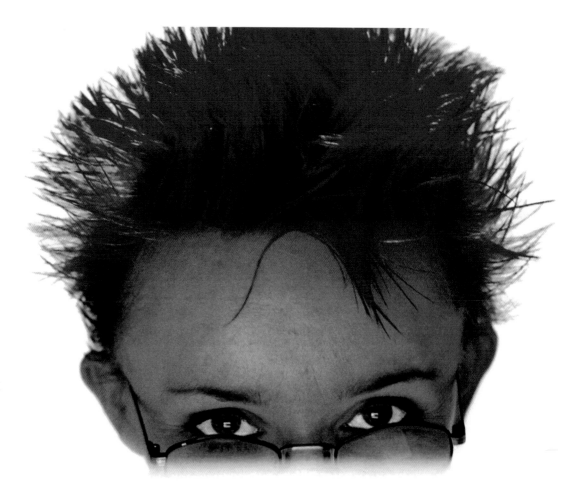

42 red hair

Believe it or not, the warehouse in which this picture was taken was extremely dark, and Neild needed all her skills to produce a winning picture in challenging circumstances.

Choosing the only white brick wall there was as her backdrop, she found a floor-standing arc light with a reflector, and angled this onto the wall to provide a crisp, clean backdrop. The light on the subject was provided by the computer you can see reflected in the subject's eyes – with the out-of-focus top of the monitor providing the soft edge above which the head seems to float.

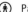 Pauline Neild

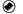 Times Higher Educational Supplement newspaper, UK

 Press

35mm

70–210mm (at 150mm)

 Fuji Superia 400

1/8sec at f/4

 Ambient light

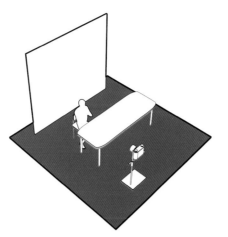

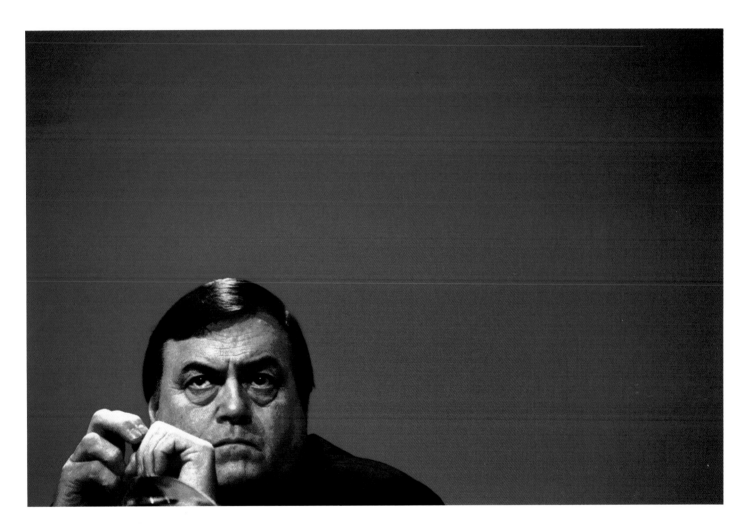

thoughtful politician

Taking pictures of politicians on a public stage imposes a number of serious limitations. You have virtually no control over the lighting (other than perhaps using on-camera flash), you may not be able to get close to the subject, and there are often only certain positions from which you can shoot.

But where there's a will there's a way, and by finding a vantage point which gave a clear expanse of red as a backdrop, and watching her subject, John Prescott, closely, Neild was able to capture a thoughtful expression as he looked up – with the overhead stage lighting providing a much-needed catchlight in his eyes.

Pauline Neild
Camera Press agency
Press
35mm
70–210mm (at 170mm)
Fuji Superia 400
1/15sec at f/4
Ambient light

This photograph captures a private moment for one of Schmidt's friends, and was part of a series that formed what was effectively an emotional diary for him.

'Because of the nature of the picture I tried to make it as natural as possible,' says Schmidt, 'and used natural light coming in from a large window on the right. Because the room was all white, the light was reflected throughout giving a soft, even tonality. No supplementary lighting was required.'

The shot was semi-posed in the sense that Schmidt caught the subject's action while she was setting up her equipment, and she simply asked him to repeat it when she was ready.

The out-of-focus objects on the wall behind are zips, and were there already – the subject is a fashion designer. Schmidt's only intervention was to ask her subject to step forward a little, so he was closer to the light and farther away from the background.

- Regina Schmidt
- Personal project
- Portfolio
- 6 x 7cm
- 110mm
- Kodak Portra 400VC
- 1/30sec at f/5.6
- Ambient light

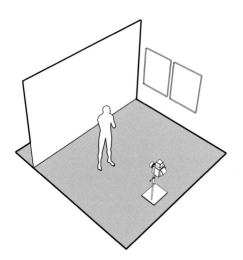

plan view

a private moment

Large white rooms provide lots of illumination that can make artificial lighting unnecessary.

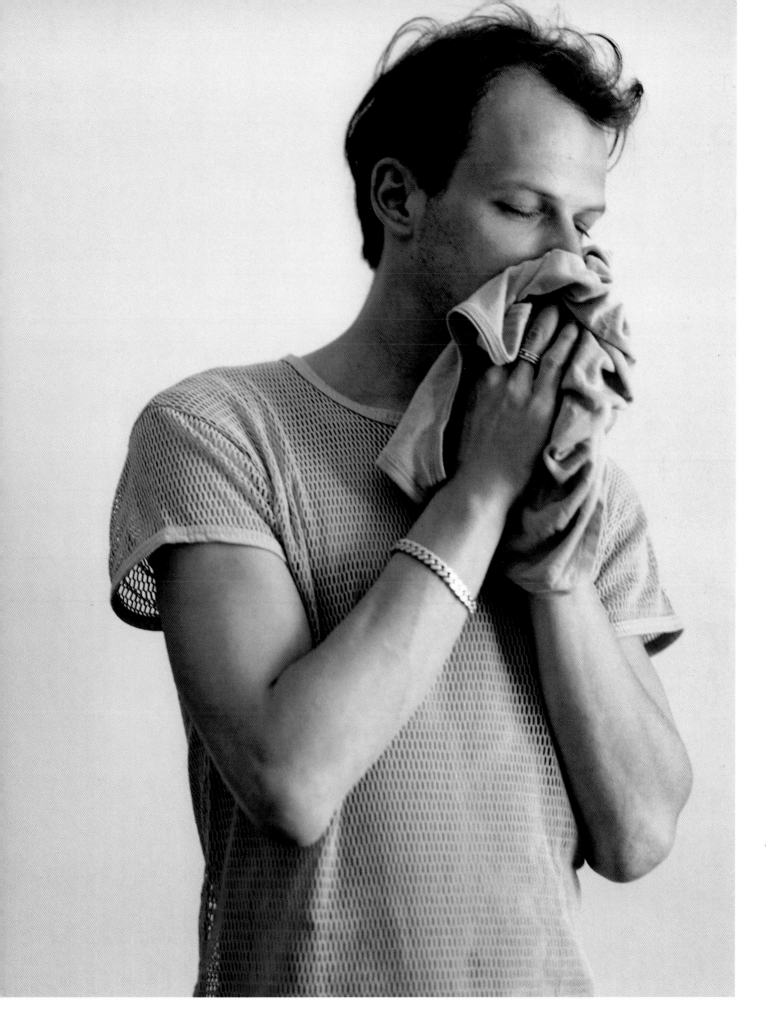

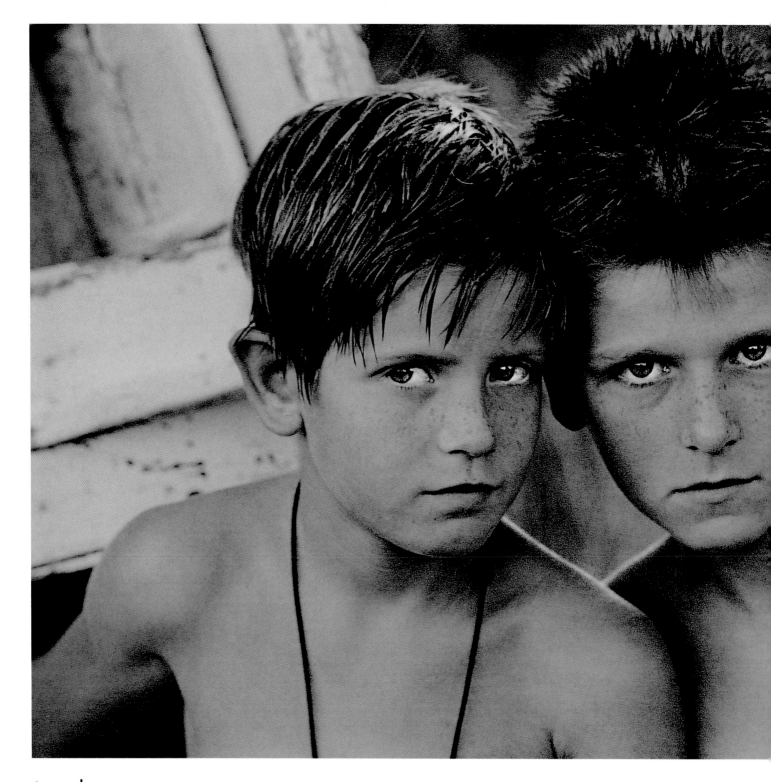

two boys

The soft lighting at the end of the day is perfect for flattering portraits.

- Tamara Peel
- Private commission
- Family record
- 35mm
- 28–105mm zoom (at 105mm)
- Agfapan APX-100
- 1/30sec at f/3.5
- Ambient light

It's a truism of photography that the quality of light is more important than the quantity, but if you wanted proof you need look no further than this picture taken toward the end of a summer's day, when the sun was low in the sky and the exposure set at just 1/30sec at the maximum aperture of f/3.5. With the sun setting behind the boys to one side, the only light directly on their faces was reflected from the sky, resulting in a flattering of the features, with only soft, subtle shadows around the eyes, nose and mouth. The really slight rim lighting was enhanced by bleaching the lith print in the darkroom.

The boys have wet hair because they've been playing on the beach all day, and the timber behind them is an old upturned rowing boat. Photographer Tamara Peel knew exactly what she wanted and asked them to put their heads together, and as they did so they looked straight at the camera. 'This was the first shot on the roll,' she says, 'and I knew when I pressed the shutter it was just perfect. I did lots of alternative treatments, but none were as good as this.'

using hand-held 35mm for kids

'I use an autofocus 35mm SLR for photographing kids because you've got to get in there quick and catch the action before it goes. With a medium-format camera you need to use a tripod, and before you know it you've lost that magical moment.'

plan view

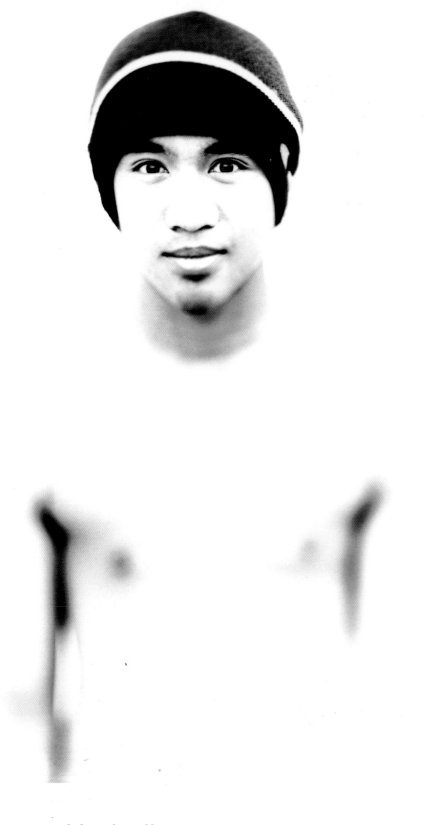

white bodies

For an alternative approach to producing a bleached-out effect, try shooting in the shade and
cross-processing the film.

These portraits appear to have been digitally manipulated, but in fact the eye-catching effect is the result of cross-processing, the use of camera movements, and careful printing.

Photographer Tobias Titz met the subjects on the street and asked them if they would pose for him. When they agreed, he arranged to meet them later for a session. Planning to cross-process the transparency film in colour negative chemistry, he deliberately chose a location that was low in contrast – the shadow side of a building. Because he wanted the background to burn out completely, he found somewhere suitable with a white wall. As the finished images show, the resulting frontal light has a strong 'fashion' feel to it, as if a large softbox has been placed over the top of the camera.

In order to have the boy's head stand out from the body, Titz used the full potential of the view camera's movements and set the lens to the maximum aperture of f/5.6.

Tobias Titz
Personal project
Portfolio
5 x 4 inch
240mm
Kodak Ektachrome E100S (cross-processed)
1/30sec at f/5.6
Daylight

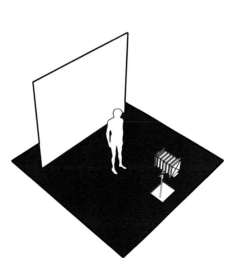

plan view

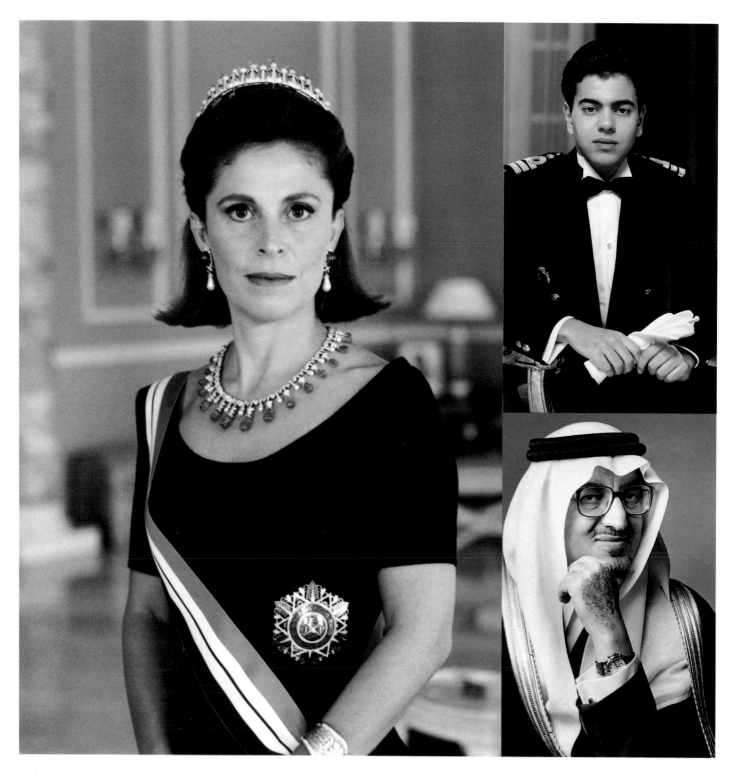

photographing royalty

Photographing royalty demands more than just photographic skills.

To have success at photographing members of a royal family you need to be more than a good portraitist. You also need the skills of a diplomat, to be respectful in what you say and what you do, as well as totally trustworthy.

Karim Ramzi has, for many years, been photographing royal families in countries such as Morocco, Jordan and Saudi Arabia. Not surprisingly, he is circumspect when talking about such commissions. 'I sometimes compare the photographer with the doctor or the lawyer – you are able to see inside their private life in a way that few people do. However, there is one difference: as a photographer you're one of the few people who give them directions, who can tell a king what to do. I see members of a royal family first and foremost as human beings, and that's what I want to capture. Sometimes they are uncomfortable because you can break their image or make their image with your picture. I'm a sincere person, and I help them relax.'

This wonderful picture of HRH Princess Taghreed of Jordan perfectly demonstrates Ramzi's skills. It was taken in the Jordanian Royal Palace, with all of the windows and doors thrown open to admit as much morning light as possible. A white sheet was laid out on the floor, to bounce light back up at the subject. The resulting 'wrap-around' illumination is soft and flattering – an effect enhanced by using black & white film and printing the image on colour paper. Using a 100mm 'portrait' lens at its maximum aperture of f/2.8 throws the potentially distracting background out of focus.

Karim Ramzi
HRH Princess Taghreed of Jordan
Various uses
35mm
100mm APO
Kodak T-Max 100 (printed on colour paper)
1/30sec at f/2.8
Daylight

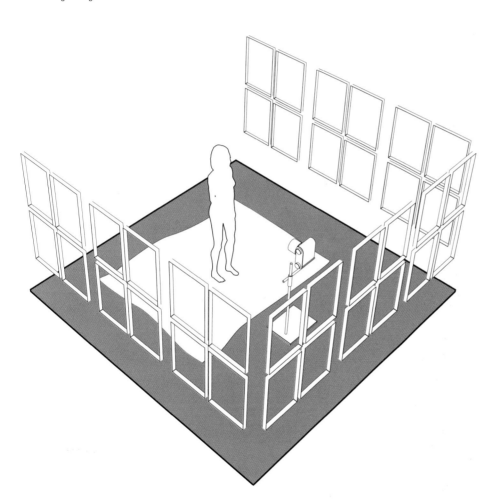

plan view

HRH Moulay Rachid of Morocco

51

For this official portrait of HRH Moulay Rachid of Morocco, a softbox was placed up high and slightly to the left.

HRH Khalid Al Faisal of Saudi Arabia

This picture of HRH Khalid Al Faisal of Saudi Arabia was taken using just one softbox positioned to avoid reflections in the glasses.

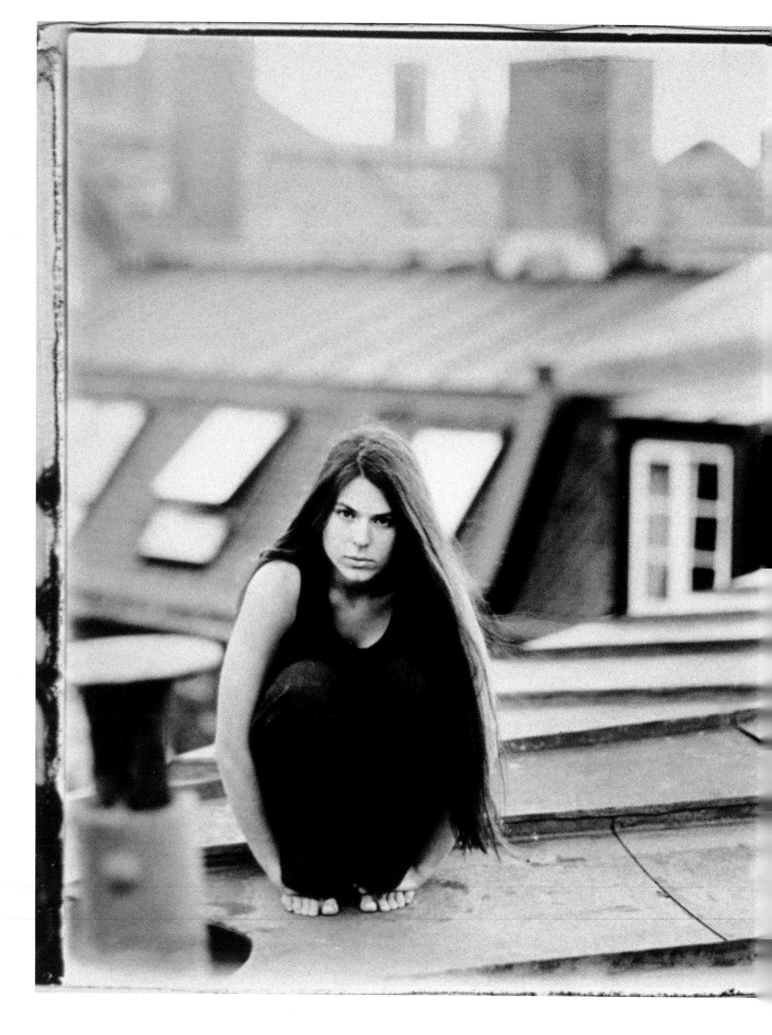

A. schickte das Buch
wack. Als er sich
umdrehte kam ihm
die Zukunft mit
offenen Armen ent-
gegen. Zu-
gleich sperrte sein
inneres Auge die Tür
wie einer Bananen-
schale.

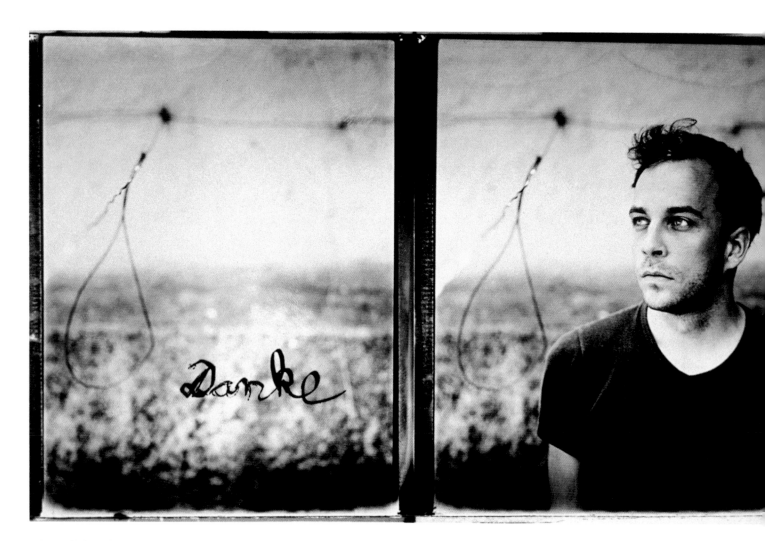

Danke

54 double image

Backlighting is essential for an unusual technique where the subjects are invited to contribute to the
creative process.

For these striking portraits, in which the subjects are invited to become active participants in the creative process, the photographer consistently used the same techniques.

In each case two negatives are taken on Polaroid film: the first is a portrait in the normal sense of the word, and the second is exactly the same but without the person – who is then invited to scratch something into the negative. This could be words, a drawing – or whatever – reflecting what they think about the photograph, and themselves, at that moment.

Because the technique requires a light background so that the 'scratches' can be read clearly, Titz always searches for an outdoor daylight location in which the light is coming from behind – never from the front.

Tobias Titz
Personal project
Portfolio
5 x 4 inch
240mm
Polaroid Type 665
1/60sec at f/5.6
Daylight

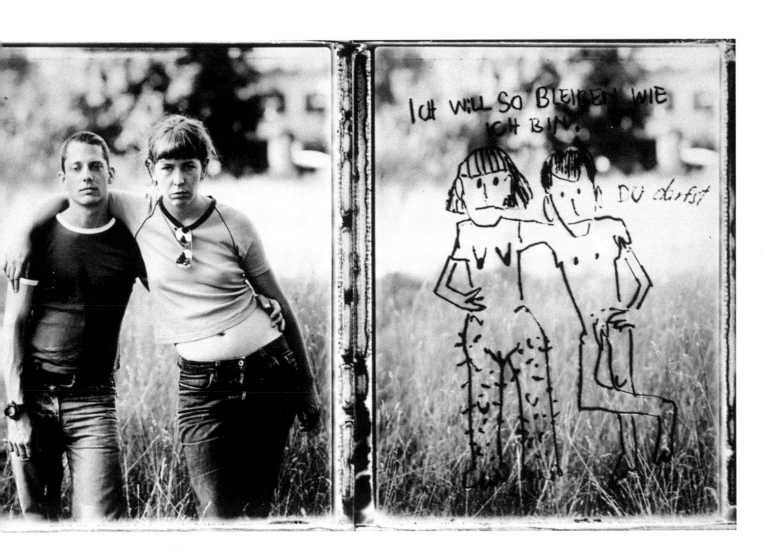

55

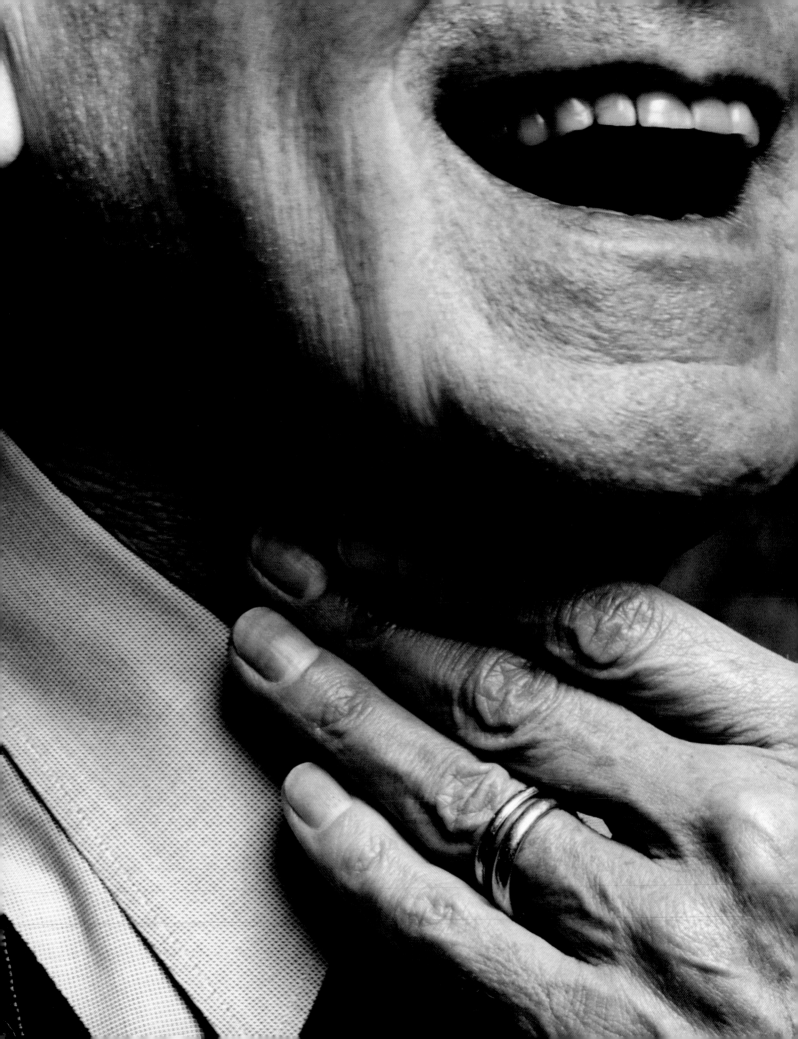

simple lighting

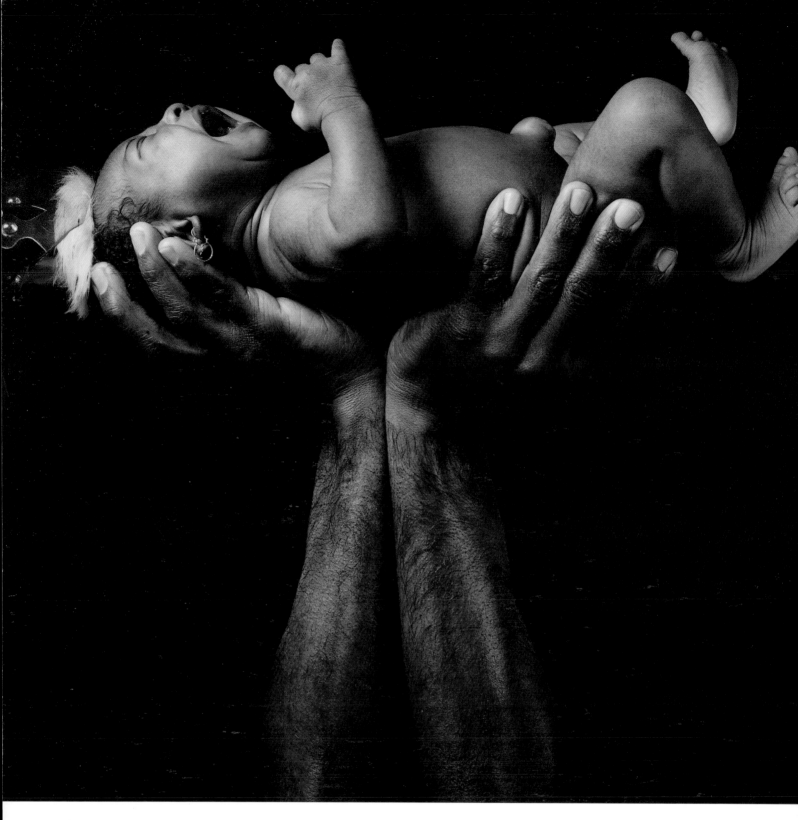

baby in hands

A single light placed high above the subject is perfect for low-key lighting effects.

Low-key images require considerable lighting and printing skill to be successful – but here the photographer has got it just right, with a full range of tones encompassing rich, deep shadows and clean, white highlights.

The secret is simple lighting, with just one head fired into an umbrella placed up high and slightly to the left, around 1m away from the subject. A white reflector helps fill in the dark areas on the right-hand side. The background is a standard black paper roll that's 4m back from the subject to prevent any light falling onto it. For a more dramatic perspective, a low camera angle was chosen.

Erwin Olaf
Personal project
Portfolio
6 x 6cm
120mm
Plus-X Pan
1/500sec at f/11–16
Electronic flash

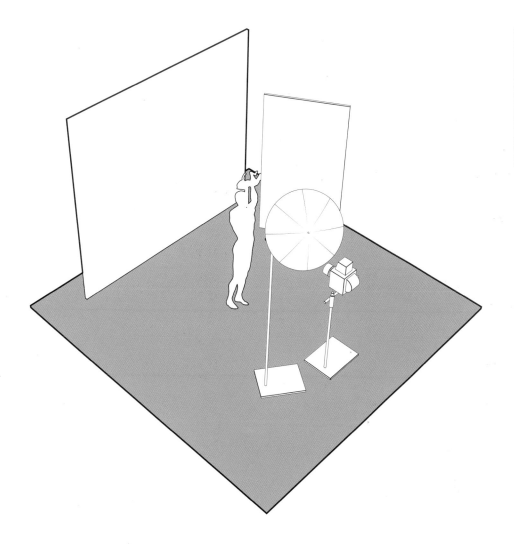

plan view

Using a low-powered burst of fill-in flash to balance the exposure with light coming in from a window is a common enough technique, but doing so in a way that produces natural, believable results takes a fair bit of skill. If there's not enough light, the effect isn't noticeable; if there's too much, the subject looks overexposed compared to the ambient light. Here the photographer has got it just right, using a snoot on a studio flash head to pick out only the subject and prevent stray light falling onto the backdrop. The blue tint was added at process stage.

(👤) Dave Willis
(↻) Private commission
(◉) Portfolio
(📷) 6 x 7cm
(◎) 180mm
(▶) Ilford FP4
(⏱) 1/15sec at f/8
(💡) Electronic flash and daylight

plan view

60 ## anakin skywalker

When using light to fill in the subject, you need to control it carefully.

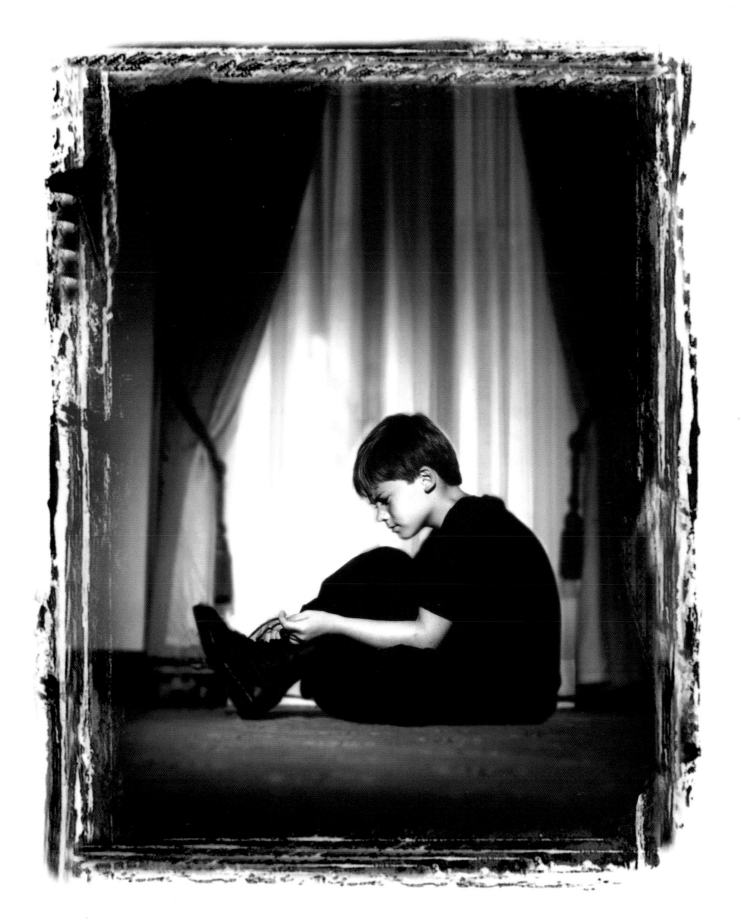

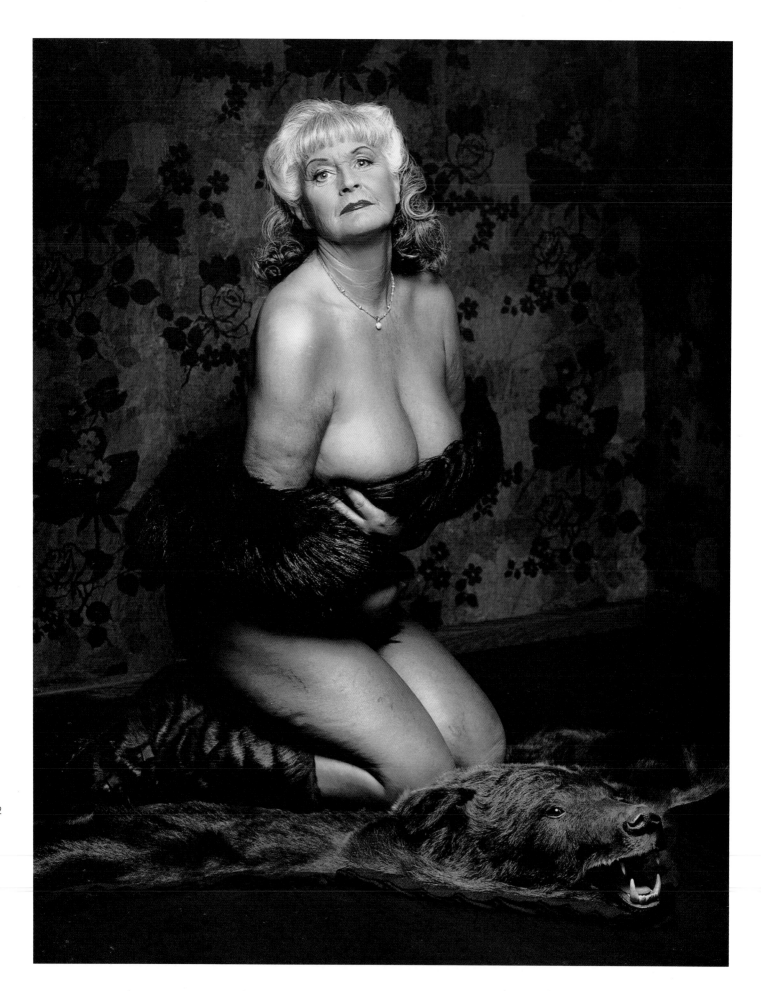

'This picture was inspired by the pin-up industry of the 1950s,' says Erwin Olaf. 'I tried to imagine how it would be if one of the models was still posing for the camera at the age of 63.'

The picture was created in the studio. The set was built to echo a fictional elderly person's home, with yellowing patterned wallpaper – and a bearskin to add a kitsch element to the shot.

Because Olaf didn't want the lighting to be flattering, he used just a single, rather unforgiving light source – a softbox positioned above the camera. This produced a heavy shadow under the chin and highlighted the wrinkles in the skin.

Computer manipulation has made a vignette of the portrait by shading off the background around the subject. It has also increased the contrast and removed irrelevant imperfections – creating a hyper-real atmosphere.

- Erwin Olaf
- Personal project
- Portfolio
- 6 x 6cm
- 120mm
- Fujicolor Reala
- 1/500sec at f/11–16
- Electronic flash

plan view

supermodel

A single softbox can be used in an unflattering way when required.

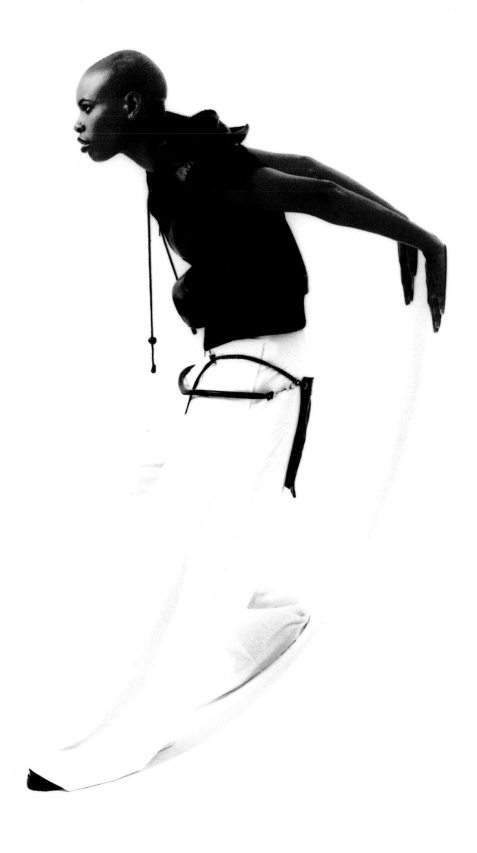

Cross-processing a slide film in colour negative chemistry to bump up the contrast often means you don't need to use so many lights. For this shot of the singer Skin, only one softbox was used. She's facing the light directly, as can be seen by the large highlight on the face. The highlights on the arms are the result of light bouncing off the white ceiling and the wall she's leaning on. Her dark skin tone accents this. The shot was printed to maintain detail in the shadow areas, which meant the lighter tones burnt out, producing a punchy, high-contrast effect.

Dave Willis
Kerrang! magazine, UK
Editorial
6 x 7cm
250mm
Fujichrome Astia (cross-processed)
1/60sec at f/8–11
Electronic flash

plan view

skin

One carefully positioned light is sometimes all you need.

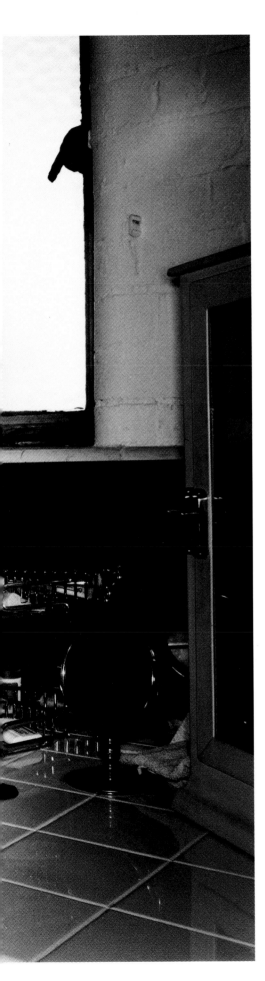

This naturalistic portrait looks almost as if it could have been a snapshot, captured casually in the middle of a party. In actuality it was a carefully constructed shot intended to create an imaginary 'dramatic moment' to illustrate a feature on bathrooms – and the expression is intended to illustrate that.

'I positioned the model so there was a strong backlight from the window, and then I balanced the exposure with lighting from the front,' says Hiroshi. A ringflash was chosen as the light source because it would give a sharper, harder illumination. The stray non-image forming light present in the image was caused by shooting into the light, providing a 'morning-after' atmosphere.

- Ⓐ Hiroshi Kutomi
- Ⓑ i-D magazine, UK
- Ⓒ Editorial
- Ⓓ 6 x 7cm
- Ⓔ 90mm
- Ⓕ Kodak Tri-X
- Ⓖ 1/250sec at f/22
- Ⓗ Electronic flash and daylight

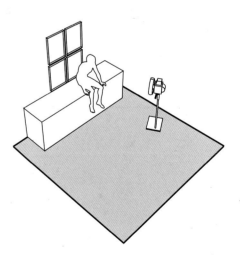

ringflash fill-in

'Casual' compositions require careful setting up.

plan view

It's difficult to guess how this photograph was created. The image was not composited digitally – actually the model is lying in an aquarium measuring 1.5 x 1.5m, which is full of milk and water. A sheet of glass was placed on top of this, onto which the egg was broken. Care had to be taken to ensure the model had ventilation at this stage. For the yolk to be large enough, they had to use a goose egg. 'This was a difficult shot to set up,' says photographer Joachim Baldauf, 'but the lighting was easy.'

All that was used was one flash head fitted with a softbox, placed, as the catchlight from the yolk clearly shows, over the top and up to the right of the camera.

- Joachim Baldauf
- Amica magazine, Germany
- Editorial
- 6 x 7cm
- 105mm
- Agfa Optima 100
- 1/30sec at f/8
- Electronic flash

plan view

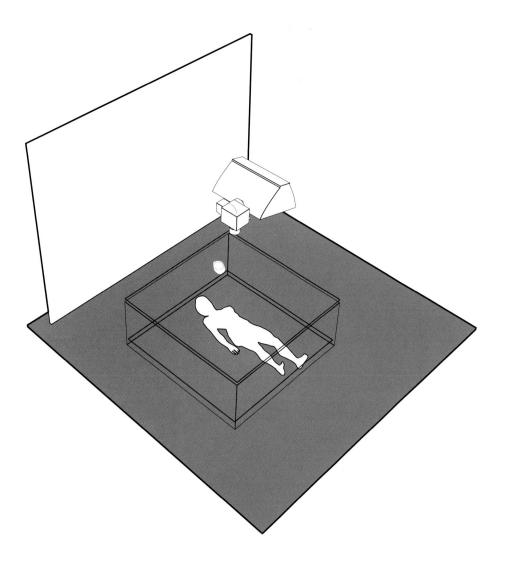

egg

Sometimes lighting is the easy part…

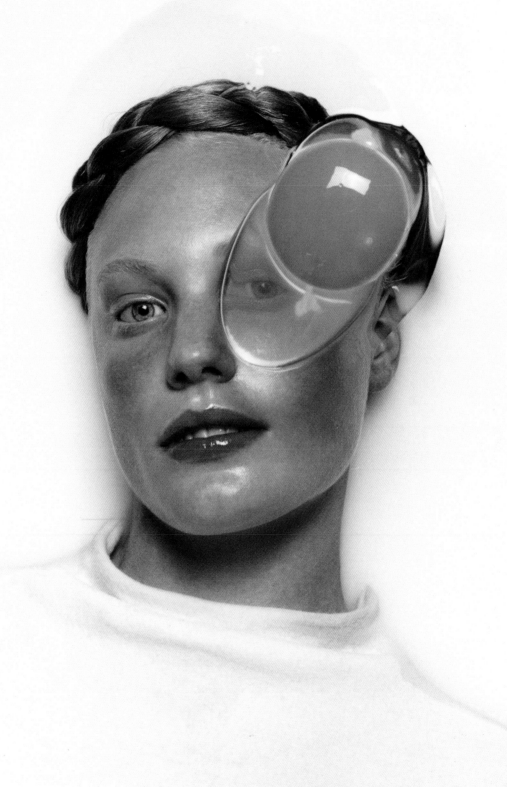

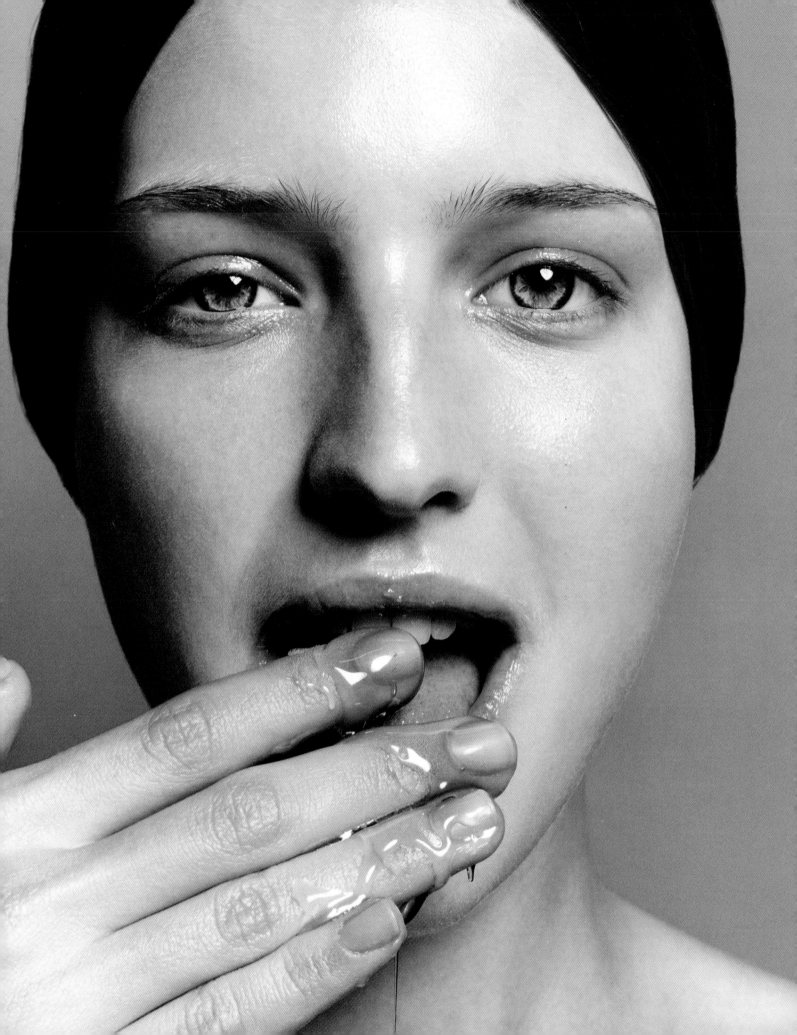

This picture was one of a series taken to illustrate the theme 'Make-up you can eat', and its great strength is in its simplicity – nothing has been allowed to take your attention away from the subject.

Cropping in tight minimises the amount of background we see – and that, in any case, has been painted virtually the same colour as the honey. The hair has been tied back to reveal the face, and the straightforward one-head set-up provides full illumination without heavy shadows. As can be seen from the prominent catchlight in the eyes, the light is a softbox, angled diagonally to provide a triangular-shaped light, up to the right of the photographer.

Joachim Baldauf
Amica magazine, Germany
Editorial
6 x 7cm
105mm
Agfa Optima 100
1/60sec at f/8
Electronic flash

plan view

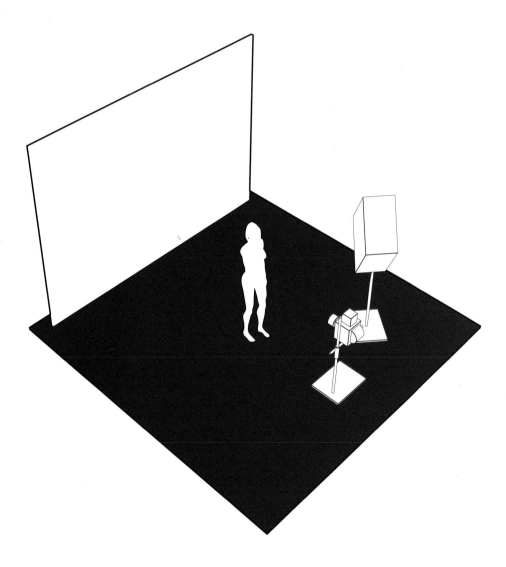

honey

A strong idea can benefit from simplicity in composition and lighting.

71

This portrait of film music composer John Barry, who wrote the James Bond theme, has a marvellously strong composition. 'I normally set the camera up on a tripod and then leave it there,' explains Guthrie, 'and if the person then moves a little you end up with an unconventional crop that can be more interesting. This image is pretty much as it was shot.'

The picture was taken at Barry's home, and includes more of the surroundings than would normally be Guthrie's style. 'I took a roll of background paper with me,' he says, 'but although I wasn't hugely comfortable with the ornate tapestries behind him, there wasn't anywhere convenient to put it up. Happily, it was possible to darken the background at the printing stage.' There's one flashlight source on the subject, up high and to the right, fired through an umbrella.

ⓐ Mark Guthrie
ⓢ Time Out magazine, UK
ⓕ 6 x 7cm
ⓛ 75mm
ⓕ Kodak Portra 160VC
ⓣ 1/125sec at f/16
ⓛ Electronic flash

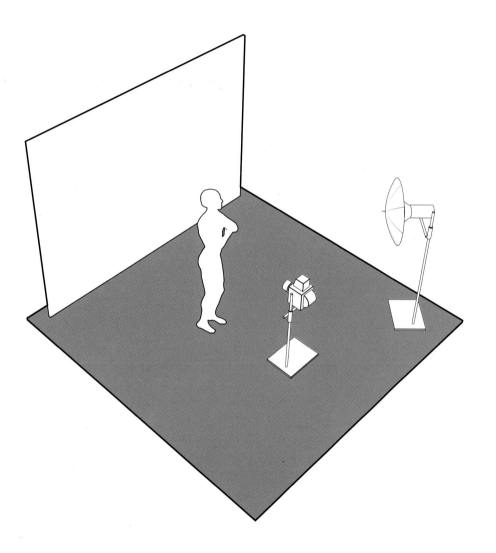

plan view

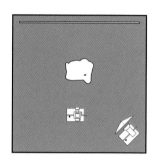

john barry

Unconventional cropping can create a more dynamic composition.

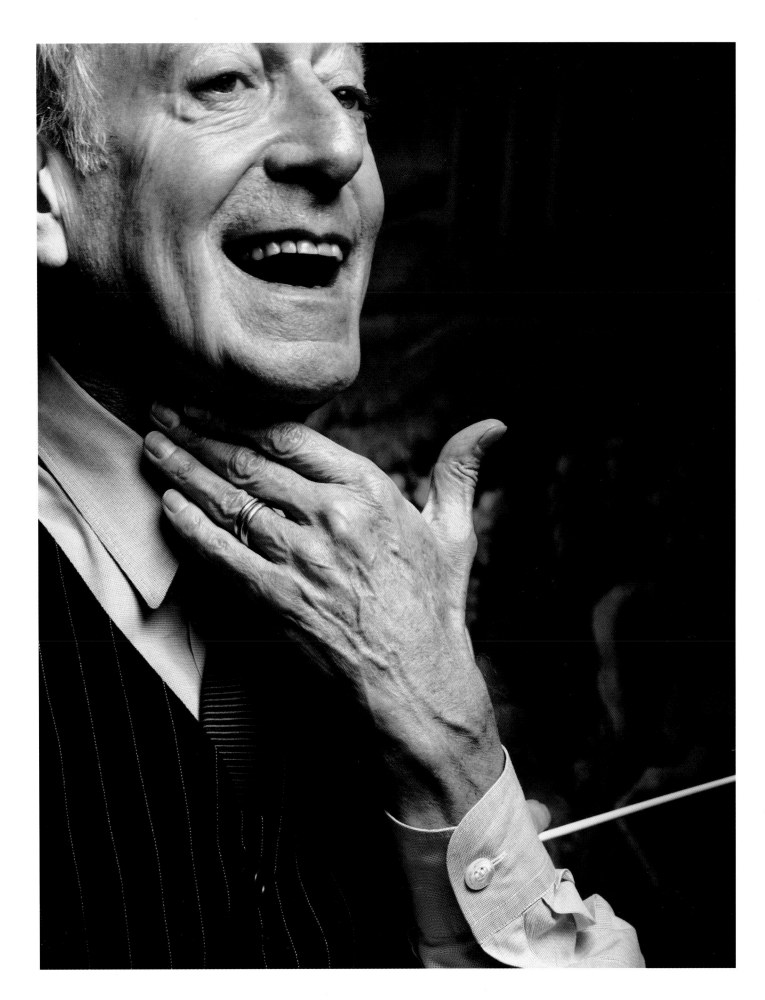

Like almost all of his black & white pictures, this shot of blues legend Linda Hopkins by Jeff Dunas was taken with just one light fired into a jumbo umbrella.

'Terence Donovan once said, "The big guy only uses one light," and I always thought he had a point,' says Dunas. 'There's a lot to be said for simplicity. Pictures taken using lots of lights can look contrived, and they date quickly. With one light source I can still create a wide range of effects by the way I position the subject, camera and light in relation to each other.'

'This picture was taken in a small make-up room, with the umbrella a few feet behind me to the left of the camera – you don't want it close to the lens, because then the lighting is flat. Here, it's not too contrasty. But if I take one step to the right, and get the subject to look at me, then it gets a whole lot punchier.'

'Using one light is also a matter of not taking too much of the subject's time. I mainly shoot famous people, and they don't take kindly to sitting around while you take endless Polaroids to check the lighting. They're not conscious of these technical kinds of things. Nor should they be. I'm not constantly fiddling with my kit, that's the sign of an amateur. A professional has to commit themselves to the subject, and spend his time with them. Everything else is a distraction.'

(人) Jeff Dunas
(☉) Personal project
(◉) State of the Blues monograph, Exhibition
(▣) 6 x 7cm
(◎) 140mm
(▥) Agfapan 400
(◷) 1/400sec at f/11
(◉) Electronic flash

plan view

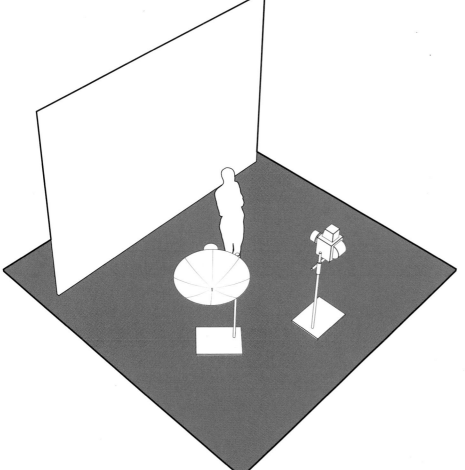

state of the blues

Using a jumbo umbrella gives lots of lighting control.

lighting the background

'Mostly I use the same light for the background, and depending upon how light or dark I want it to be, and/or the person's skin colour, I'll just simply put the subject closer to or farther away from the background. It's as simple as that.'

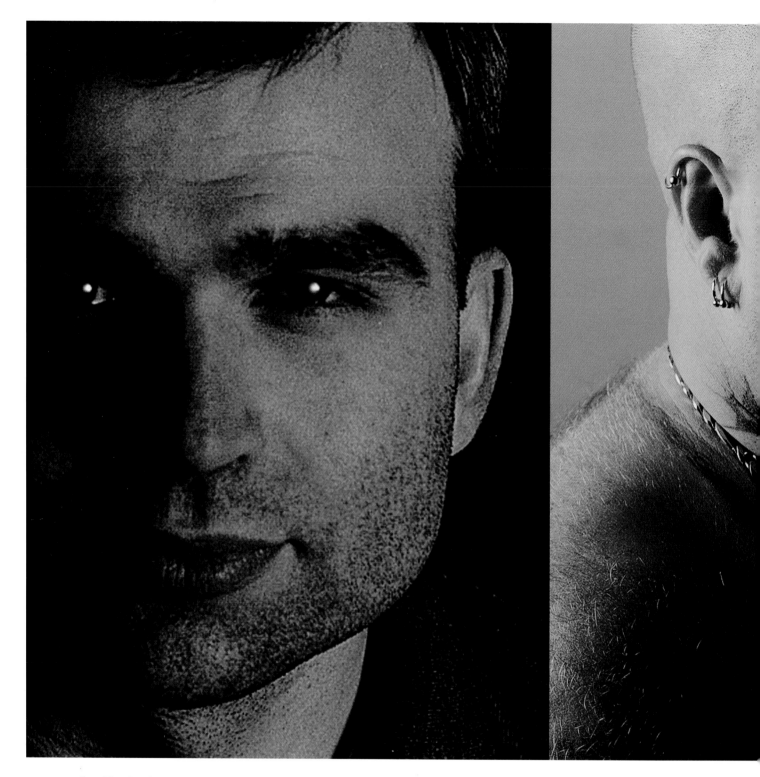

moody lighting

When using just one light, small alterations in its position can make a big difference to the effect.

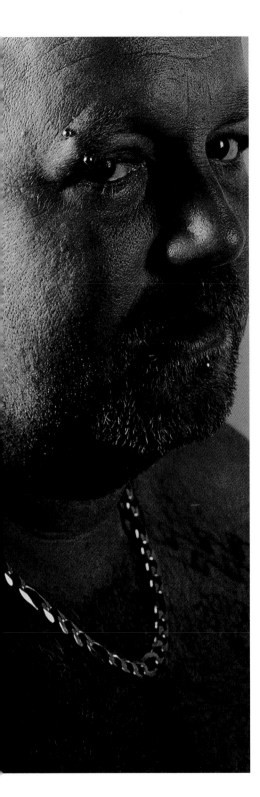

Both of these pictures were taken using just one softbox – but it's where it's placed that makes all the difference. The further you take it around to the side, the moodier and more dramatic the result.

For this shot on the left, the photographer placed the light at right angles to the camera, so only one side of the face was illuminated – throwing the opposite side into complete darkness, and bringing out the texture of the stubble. 'I knew from the shape of his face that he would appear really moody if shot in this way,' says Parker, 'and although I also did a series with the light at 45 degrees, they didn't work anywhere near as well.'

For the tattooed man, the softbox was moved to the left side, and has been brought a little closer to the camera – although it's still farther round and slightly higher than usual. Doing so helps reveal the contours of his physique while ensuring the tattoos are not overlit.

Sepia is considered old-fashioned, but using it for a modern shot can give an 'authentic' and so powerful feel. Here, it helps to bring all the elements of the subject's body enhancements together.

In both cases the framing is unconventional, with tight, off-centre cropping. Parker believes in breaking the rules to produce images that are more eye-catching.

Karen Parker
Personal project
Portfolio
6 x 7cm
110mm
Agfapan 100
1/60sec at f/8
Electronic flash

plan view

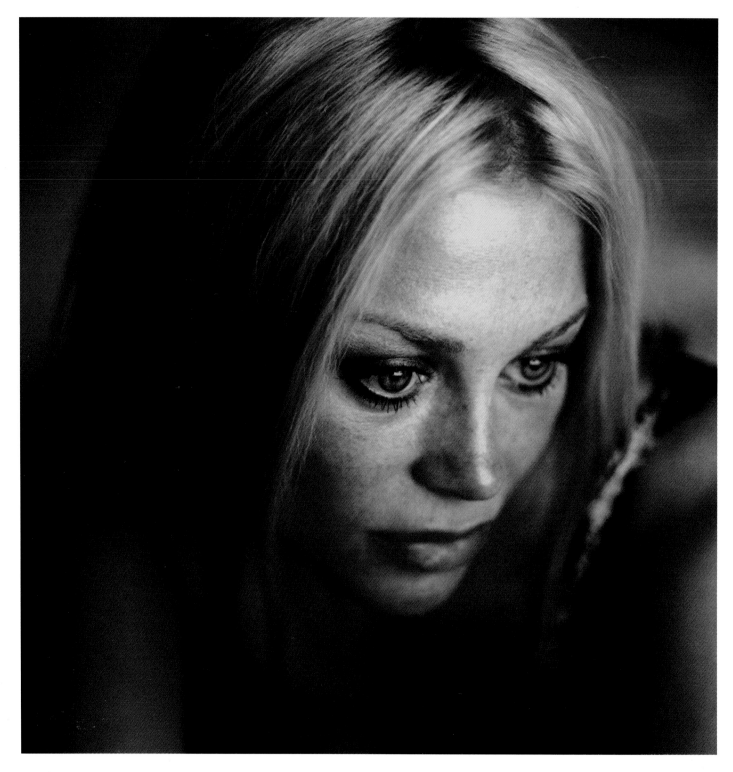

colette page

Try using just the modelling lights for a more relaxed mood in the studio.

The pop of a flash going off every few seconds can be distracting for subjects and can interrupt the mood of a session. One alternative is to employ studio lighting but to use only the modelling lights – which is what the photographer did here.

One studio flash head was diffused by a softbox and placed over to the right and slightly above head height – giving the classic effect of light coming in through a large window. Using just the modelling lights, however, means there's a lot less light to work with, and here, with an ISO 400 film loaded, the best that could be achieved was 1/15sec at f/4. The limited depth of field, though, has been put to excellent use, bringing a sense of intimacy to the shot. The tonal warmth produced by the tungsten lights was filtered out at the printing stage.

- Matt Moss
- Personal project
- Portfolio
- 6 x 6cm
- 110mm
- Kodak Portra 400 NC
- 1/15sec at f/4
- Modelling light

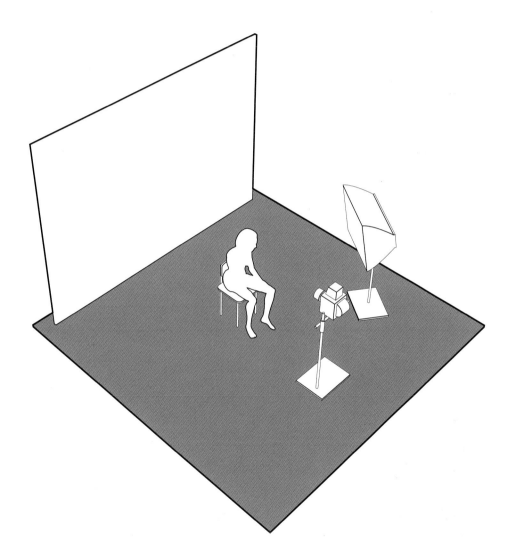

plan view

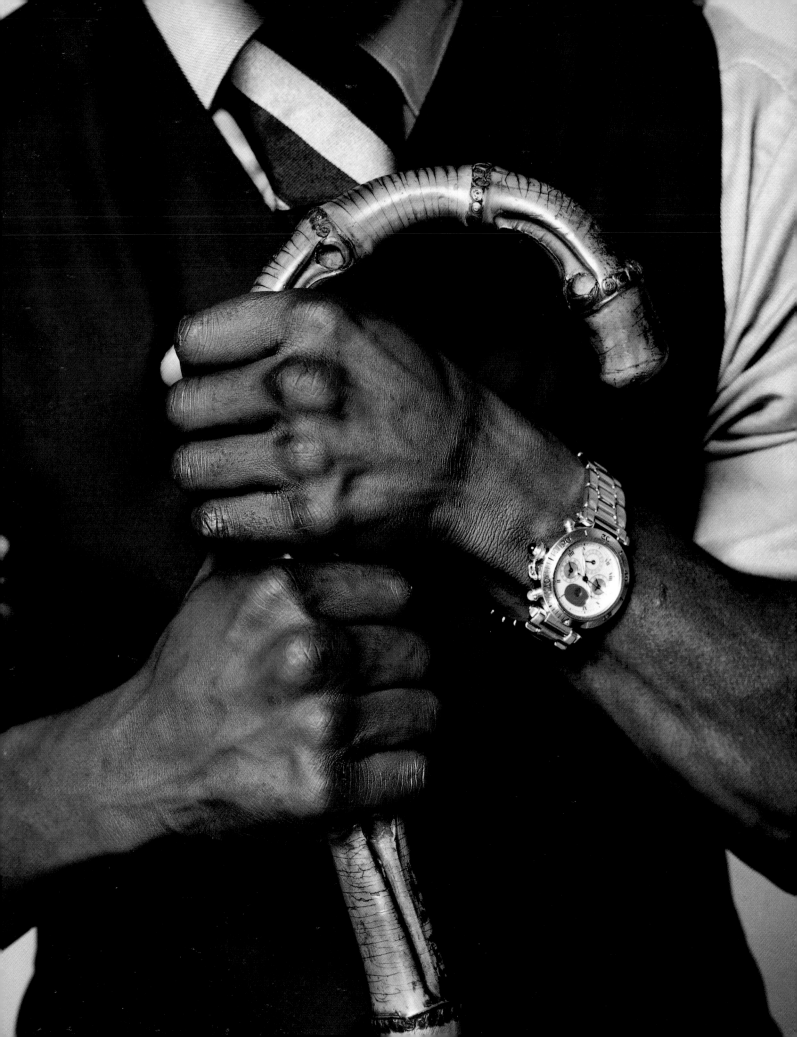

'I like to bring out something of the character in the people that I photograph,' says Karim Ramzi, 'and that means paying attention to more than the face. With Chris Eubank, it was the extravagant aspect of his personality that interested me, and of course – since he was a boxer – his hands.'

All of the items in this wonderful close-up belonged to Eubank, and the composition is as much a beautifully arranged still-life as it is a portrait. Contributing to that is the simplicity of the lighting: just a small softbox over the camera, with a reflector below to provide fill-in.

Karim Ramzi
Personal project
Portfolio
6 x 7cm
150mm
Kodak T-Max 100
1/500sec at f/11
Electronic flash

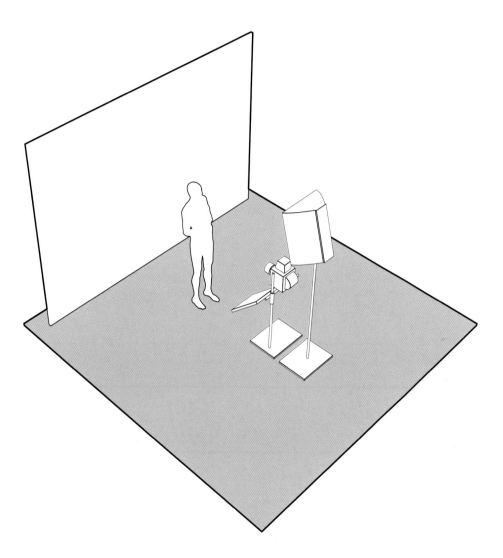

plan view

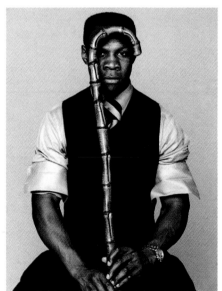

eubank's hands

If you're looking to sum up the character of your subject, use every means at your disposal.

softbox size

81

'Although I have tons of lighting in-studio, I like to keep things as simple as possible, and use just one light fitted with a softbox for most of my photography,' says Ramzi. 'My favourite is relatively small, just 1.2 x 0.8m. It gives a rather contrasty light that tends to bring out the features of the subject and gives texture to the face. I also have a large softbox, but I rarely use it. When I travel I take just two lights, one to use and the other as back-up.'

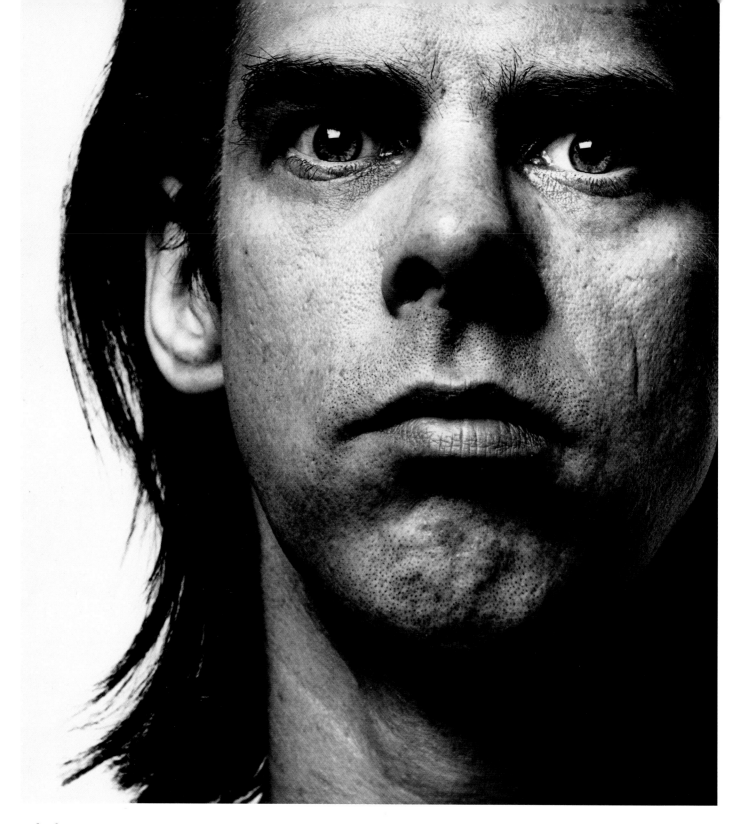

nick cave

Tight cropping, frontal lighting and a direct expression combine to produce a compelling portrait.

They say the eyes are the window to the soul, and this picture shows how powerful they can be when photographed well. By going in close and lighting the subject simply, an arresting expression has been captured.

Just one softbox was used, positioned to the left of the photographer and raised slightly above head height. 'Nick Cave doesn't like being photographed at the best of times,' says Guthrie, 'and for the first roll of film there was a bit of a stare-out.' With the tight crop and the use of a medium aperture the depth of field was extremely limited – with the tip of the nose and the ears ending up out of focus. The use of the slow and fine-grained black & white film Pan F, together with the 6 x 7cm format, means that every detail of the complexion is recorded.

Mark Guthrie
Time Out magazine, UK
Editorial
6 x 7cm
90mm
Kodak Pan F
1/125sec at f/8
Electronic flash

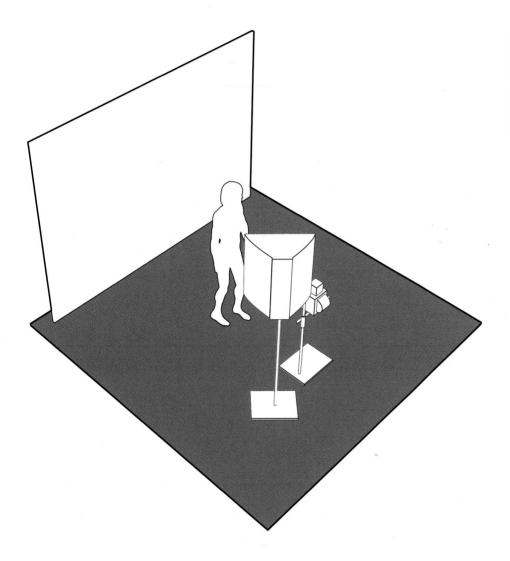

plan view

catchlights

In the majority of portraits, the eyes are the most important element. If the eyes lack sparkle, the picture can look flat and fail to engage the viewer. One of the easiest ways of bringing a portrait to life is to make sure there is a point of light or 'catchlight' in the eyes – and this is easily achieved no matter what the lighting arrangement. Simply place a point source of light or a reflector close to the lens, and you'll automatically see it reflected in the eyes.

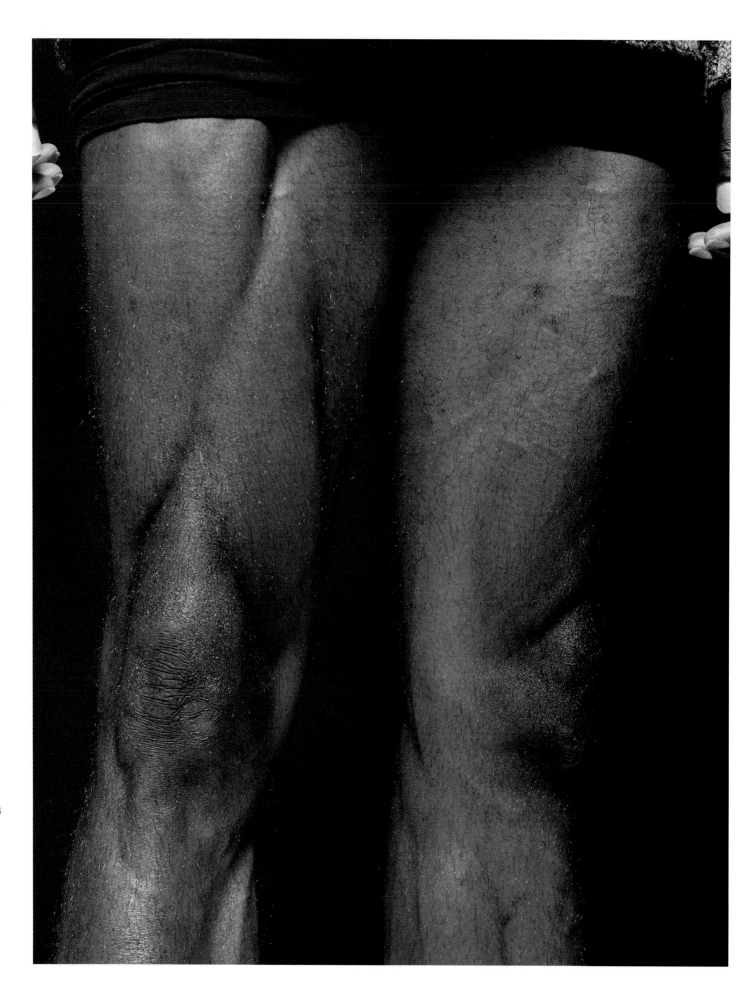

A portrait is a likeness of an individual, and doesn't necessarily have to show the face. If the subject is famous for some other part of him or her, then it makes a lot of sense to show that instead.

'I was taking some pictures of the athlete Linford Christie,' says Guthrie, 'and because he's known for his legs I suggested at the end of the session that it would be interesting to photograph them as well. He was wary at first, but finally agreed.'

Illumination came from a studio flash head fitted with a softbox that had a sheet of perspex over the front, producing a warm and diffused light. The light to the left of the photographer had been positioned to illuminate the face and upper body, and was simply angled down when the leg pictures were taken. The relatively high position helps reveal the well-developed muscle definition. A simple black paper backdrop helps the subject stand out, and leaving the hands in helps to frame the shot.

Ⓐ Mark Guthrie
Ⓒ Untold magazine, UK
Ⓕ 6 x 7cm
Ⓛ 110mm
Ⓕ Kodak GPH
Ⓣ 1/125sec at f/11
Ⓘ Electronic flash

plan view

linford christie's legs

There's more to photographing people than their faces.

While on-camera flash is far from ideal for many subjects, it can be used to give an exciting 'reportage' or 'press' effect in certain situations. It is also ideal when you have to work quickly and don't have time to set up further lighting. For this grab shot, a powerful gun fitted on a bracket to the left of the camera produces characteristic frontal lighting with a shadow behind.

To include some of the ambient light and to produce a little movement, a shutter speed of 1/4sec was used, rather than the faster flash sychronisation speed, which would have been an option.

- 🏃 Matt Moss
- 🌀 Personal project
- ◉ Portfolio
- 🎞 6 x 6cm
- 🔘 50mm
- 📼 Ilford HP5
- 🕐 1/4sec at f/11
- 💡 Electronic flash

plan view

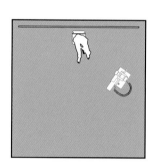

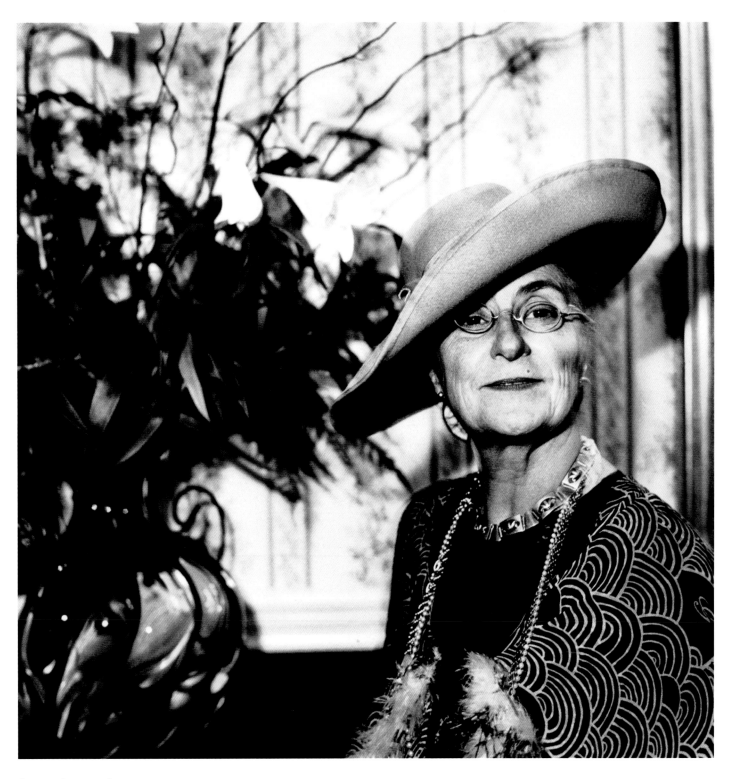

jessica destee

On-camera flash needs using with restraint, but it can sometimes be just the right approach.

jk of jamiroquai

How to get something unique from a well-photographed subject.

Mark Guthrie

Untold magazine, UK

6 x 7cm

90mm

Kodak Pan F

1/125sec at f/8

Electronic flash

88

Producing unique images of a musician promoting an album or tour can be extremely challenging, because you know they're going to be seeing other photographers wearing the same clothes. This was a particular concern for Mark Guthrie when producing a series of shots of JK from the group Jamiroquai. Known as 'the cat with the hat', JK's always seen wearing one – and he turned up for the session in a distinctive striped design.

'We knew he'd been doing other press that day,' says Guthrie, 'and we didn't want our shots to look the same, so we tried to persuade him to take it off, but he wouldn't. So we dashed downstairs to the bar of the hotel where we were taking the pictures and got a cigar, which he was happy to use as a prop in some of the shots. However, the best shot of the whole session – which was used as a double-page bleed – was taken when he turned round suddenly, took a drag of the cigar, dropped his hands, and smiled.'

The result was this apparently relaxed and natural image, which belies the skill that went into creating it. The light came from a shoot-through brolly just above eye level, and because the session was held in a small room with a lot of white walls, Guthrie wasn't too worried about where his subject was in relation to the light. 'As I was taking the pictures he was moving up to 1.5m either side of where the light was initially set, but because of the white walls it didn't really matter exactly where he was when I fired the shutter release.' In fact, as the shadows indicate, the light was slightly to the right of the photographer. Although there are not catchlights in the eyes, it's a tremendous shot considering the circumstances under which it was taken.

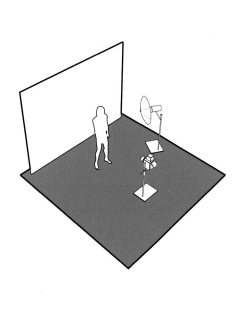

plan view

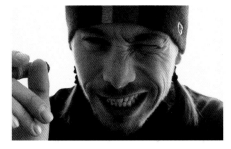

candid camera 89

This picture was taken candidly against the light using hand-held 35mm equipment. Although technically not a match for the larger image – in that the contrast and definition are lower, and there is more than a little flare – the spontaneous expression works really well.

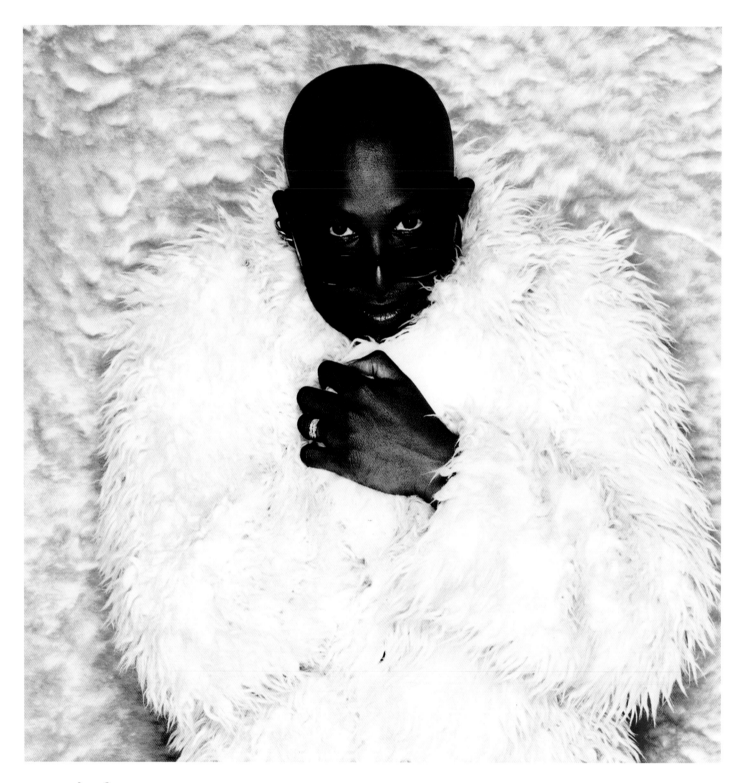

man in fur coat

If you have a large softbox, you can improvise the effect of a ringflash.

The effect you get from a specially designed ringflash can be extremely appealing, but it's hard to justify the significant investment if you're only likely to use it occasionally. However, if you've got a large softbox it's possible to improvise the effect by standing directly in front of it to take the photograph – and that's what the photographer did here. The result is a horseshoe-shaped light source that illuminates the subject directly from the front, creating the characteristic shadow all around.

Standing a 6 x 4ft polystyrene board each side of the subject increases the softening effect by preventing the shadows from becoming too dark.

Ⓐ Dave Willis
Ⓢ Private commission
Ⓟ Publicity shot
Ⓕ 6 x 7cm
Ⓛ 180mm
Ⓕ Fujichrome Astia (cross-processed)
Ⓒ 1/60sec at f/11
Ⓔ Electronic flash

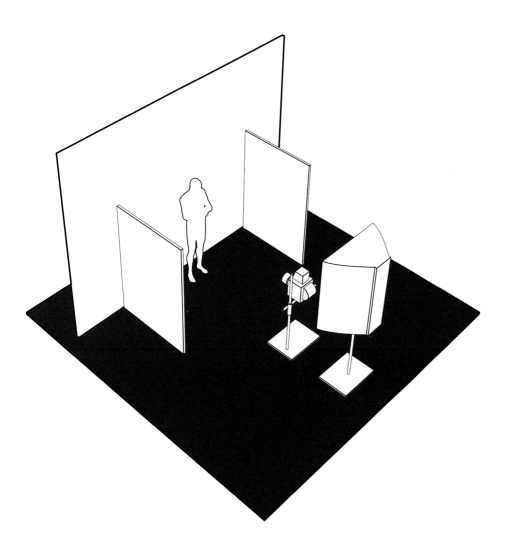

plan view

background story

Rather than keep using the same old backgrounds, try being more imaginative. Here the fluffy foam backdrop, complementing the subject and his flamboyant coat perfectly, was sourced from a toy packaging company.

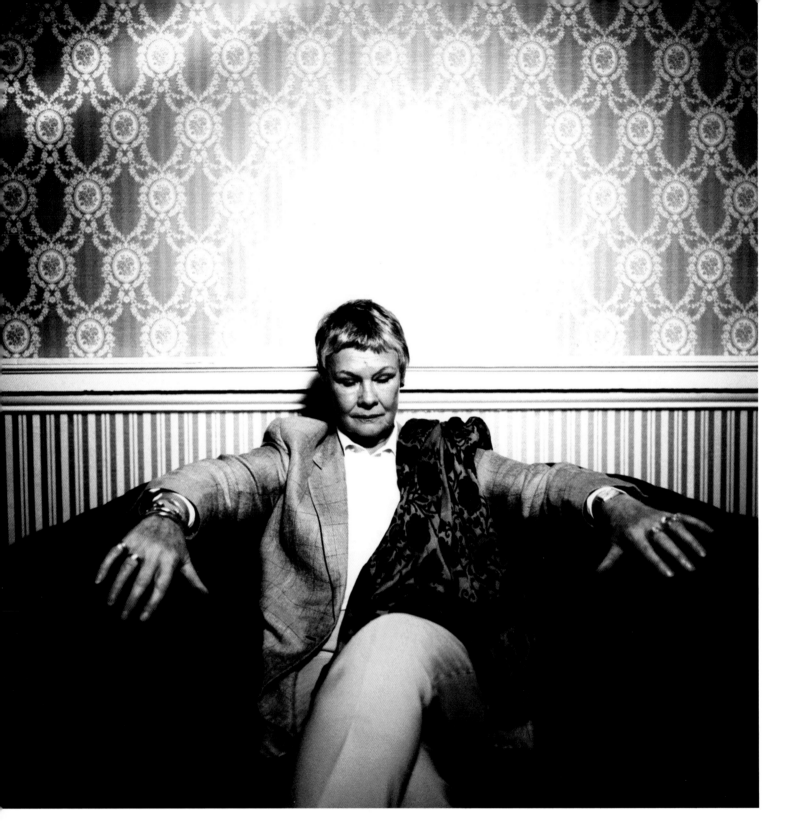

judi dench

A single tungsten head is a simple and effective solution when you don't have much time with subjects.

'I prefer to use as little equipment as possible,' says Matt Moss, 'because with celebrities you often don't have very long, and there's not much time for setting up.'

Here Moss had the chance of just a handful of shots, and so a single tungsten light source fitted with a fresnel lens and barn doors was ideal. The light was positioned just to the right of the camera and slightly above. The light was focused onto the wall above actress Judi Dench, and the film was cross-processed. The printing technique increased the contrast, and meant the area above the head has burnt out in an interesting way. (The line of light running diagonally across the top-left-hand corner was unintentional – having bled through a gap in the barn doors). Using a continuous light source without a filter and then cross-processing inevitably leads to distorted colours.

A wide-angle lens was employed at close to maximum aperture, and this opened up the perspective of the rather small room and gave a shutter speed that allowed the camera to be hand-held.

Ⓐ Matt Moss
Ⓒ Personal project
Ⓟ Portfolio
Ⓒ 6 x 6cm
Ⓒ 50mm
Ⓒ Kodak EPP (cross-processed)
Ⓒ 1/30sec at f/5.6
Ⓒ Tungsten

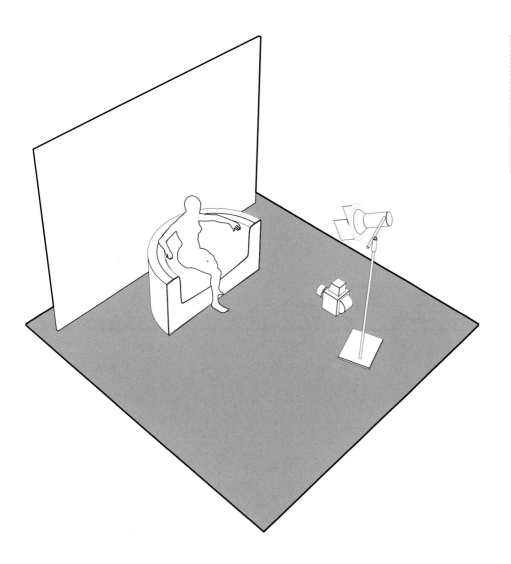

plan view

93

tony blair

When time is of the essence, it's best to keep your lighting simple.

Mark Guthrie
Untold magazine, UK
Editorial
6 x 7cm
110mm
Kodak Portra 160VC
1/125sec at f/5.6
Electronic flash

When photographing leading statesmen, you often have an unfeasibly short time in which to take your picture and so have to work incredibly fast. Guthrie says, 'I had literally three minutes with British Prime Minister Tony Blair in his private office at the Houses of Parliament. I was a bit concerned about the heavily patterned velvet background and the wooden panelling at just above waist height, but I couldn't put up a backdrop, so the only option was to limit the depth of field with a medium aperture. It was a really tight space, and he was only about 1.5m in front of the wall.'

With speed of the essence, a single electronic flash head fired through a transparent umbrella provided the lighting. Placing it above the photographer and to his right produced a more sculptured result than positioning it frontally.

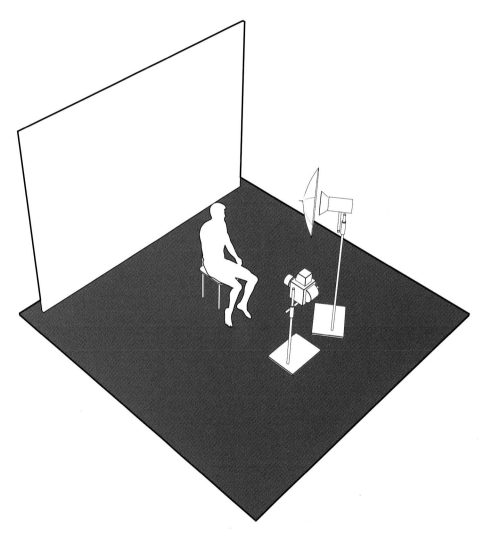

95

the approach

'I'm not an environmental portraitist. I'm more interested in cropping in reasonably tight and showing as much of the character and personality as I can capture in the time available. I try to find out as much as possible about the person beforehand, and why I've been asked to photograph them. That way you can quickly get a conversation going and build up a rapport with them. I know what I'm after, and rather than go for three or four different shots with different backgrounds, I'll just keep going until I've got it – then I'll just say "Thanks very much".'

the plane designer

Mixing flash with fluorescent helps the subject stand out from the background.

Normally you'd do all that you can to avoid having things growing out of your subject's head, but in this case the photographer decided to break the rules and deliberately composed the shot in this way. The subject was a plane designer, so a wind tunnel was the perfect location. The lighting, though, was far from ideal – it was entirely fluorescent and certain to result in an unpleasant green cast. Fortunately, Wenham-Clarke was able to get cables in, and set up a single softbox to illuminate the subject – leaving the lights behind him on and using a long shutter speed to balance the exposure.

Regarding the spectacles, Wenham-Clarke comments, 'I place the light reasonably high up and get the subject to drop their chin so they're not looking at the light. Luckily modern glasses, with their anti-reflective coatings, are easier to work with; often you just need to get people to turn their head a little.'

- Paul Wenham-Clarke
- British Aerospace Systems
- Graduate recruitment brochure
- 6 x 6cm
- 50mm
- Fujichrome Provia 100
- 1/2sec at f/8
- Electronic flash and fluorescent light

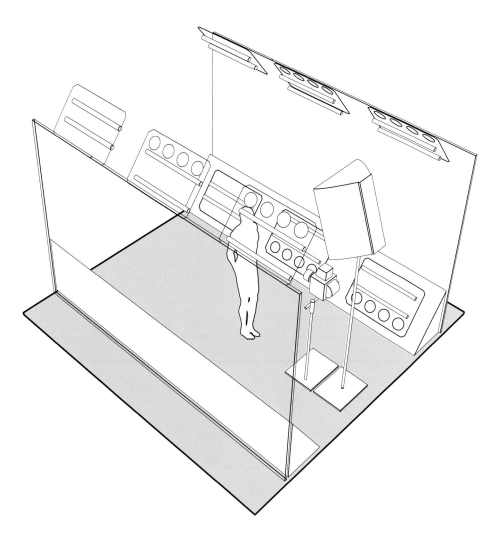

plan view

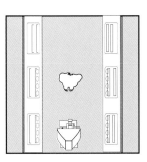

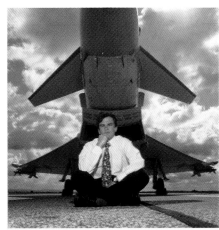

using a wide-angle lens

'I don't like portraits that look flat, which is why I often use a wide-angle lens. It allows you to incorporate a lot of background, and it exaggerates the perspective. So long as you don't get too close to the subject, there's no unacceptable distortion.'

This cleverly composed image for the same company continues the theme. Lighting is provided by a portable flashgun held as close as possible to the subject by an assistant to avoid the foreground being too bright. The shot was composed to create a near-silhouette of the plane, and the sky was underexposed to give it a dramatic and moody atmosphere.

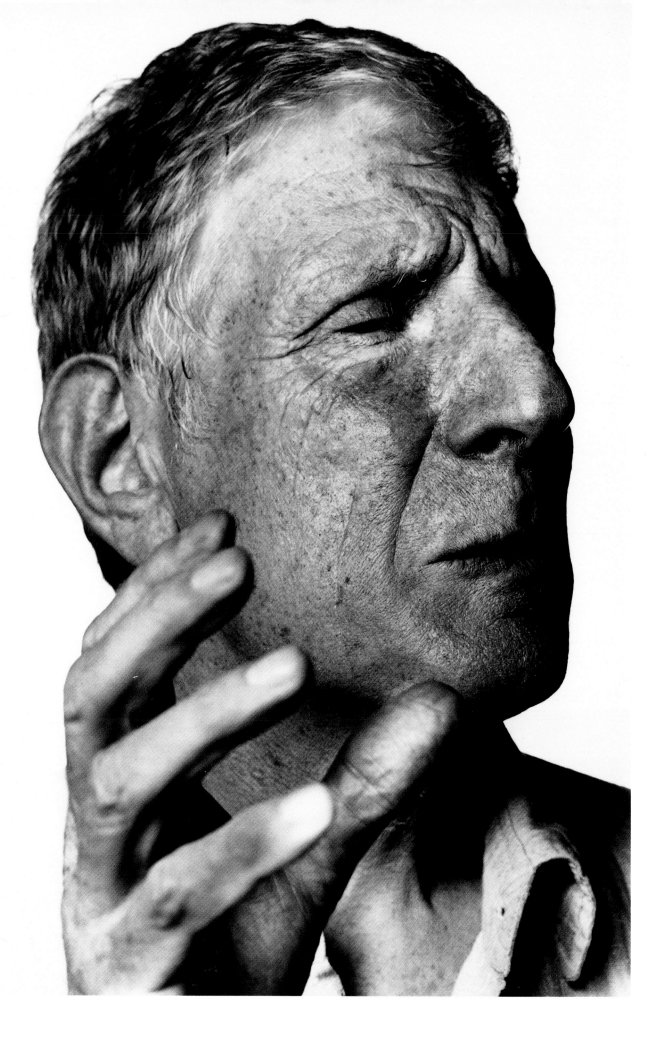

This photograph has a wonderfully sculptural quality, with the modelled, out-of-focus hands standing out from the crisp, contrasty face, and the face itself projected forward from the clean white background.

The picture was taken during a half-hour break in a theatre workshop, and there was sufficient time to put up a white paper backdrop and light it separately. The head and stand are blocked by the subject – playwright Jonathan Miller – who is lit by just one softbox that's slightly to the left. Although initially restrained, Miller became more animated during his conversation with the photographer, and this is one of several superb images captured during the session.

At the printing stage the right shoulder was taken out, so as to strengthen the line of the hands, and a hard grade of paper was chosen to produce a punchy finished print.

🚶 Mark Guthrie
🐦 Time Out magazine, UK
📷 6 x 7cm
🔵 90mm
🎞 Kodak Plus-X
🕐 1/125sec at f/22
💡 Electronic flash

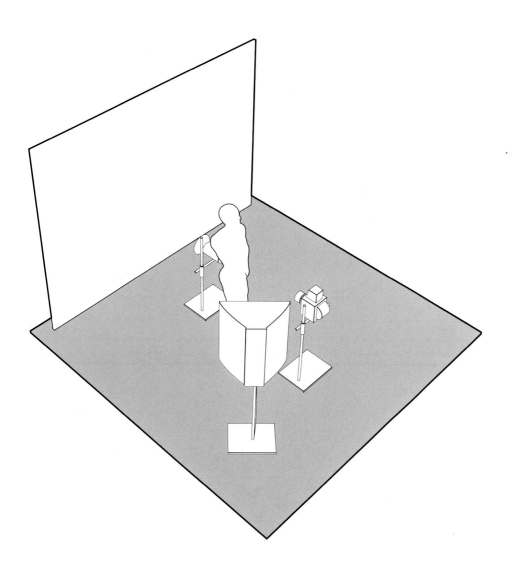

plan view

jonathan miller

Bring a three-dimensional quality to a portrait by using an out-of-focus foreground.

using one light

'Because of the circumstances under which I often work, I've learned how to get good results using the minimum of lights. Most of the time I rely on just one, and the most I ever use is two. What I like to do is go in close and get as much animation out of the person as possible. I don't have time to go for any great depth in terms of capturing their personality or character – I just aim for something lively.'

99

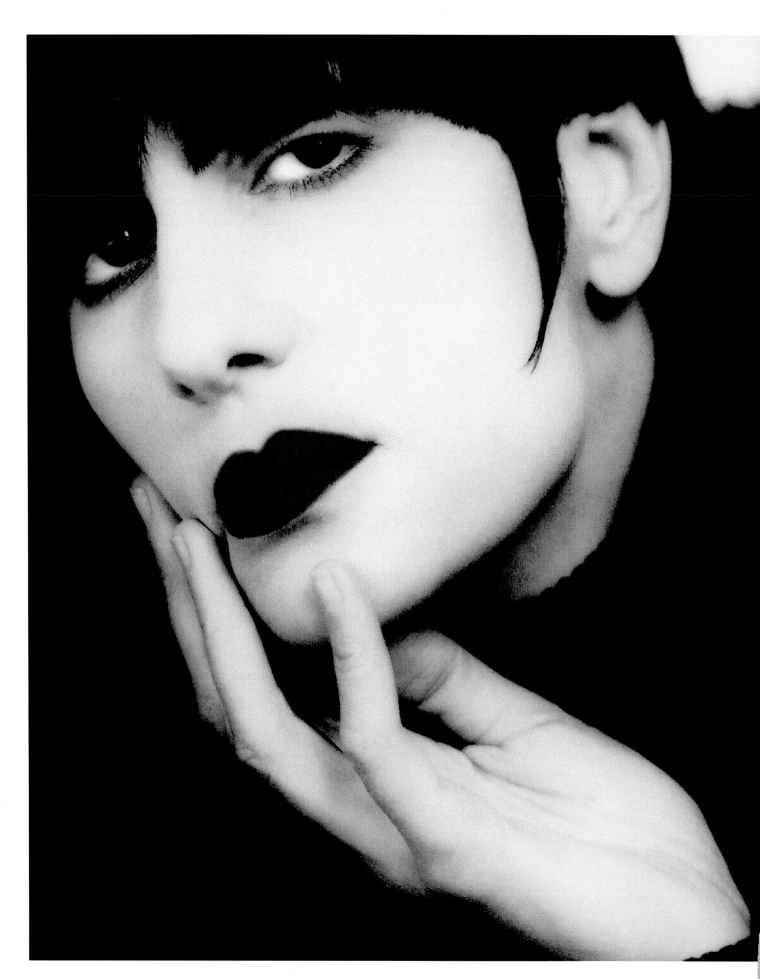

It's amazing how often the first photograph taken during a session proves to be the best – as this picture of pop star Marcella Detroit shows. It was a Polaroid, taken on Type 55 pos/neg film, prior to shooting on roll film. However, it proved to be the best of the bunch and was used for a variety of purposes, including a CD cover.

The lighting could not have been more simple. A single softbox was placed on the right of the camera. This was supplemented by two 6 x 4ft poly boards on the left to bounce light back in, evening out the tones. The image was then printed on contrasty paper and the face, lips and eyes coloured in by hand.

- Fin Costello
- Observer newspaper, UK
- Editorial
- 6 x 6cm
- 80mm
- Polaroid Type 55
- 1/250sec at f/5.6
- One studio head and reflectors

plan view

marcella detroit

101

Flooding the subject and background with soft light gives a light, airy feel to the picture.

blending ambient and flash light

Focusing on the lighting skills of Mark Leightley

While working successfully with the existing light and being able to arrange your own set-ups are both undeniably key portrait skills, it takes a special talent to be able to blend the two seamlessly. One photographer who has perfected the technique of bringing ambient and flash light together in a harmonious and attractive way is Mark Leightley. 'It's something I've practised over the years,' says Leightley, 'and now it's pretty much second nature. I like whenever possible to add to the light that's already there, rather than completely replace it. The first thing I do is to look at all the different sources of light and where they're coming from – it's not just a matter of walking into a situation, setting up your flash heads, measuring the light falling on your subject, and taking a picture. I take an ambient light reading of the background, a reading of the subject with the flash, and a third reading of the background as it's lit by the flash. I then set a shutter speed somewhere between the two. I'm acutely aware that there's often a lot of light directed all over the place, and it's all too easy to get caught out.'

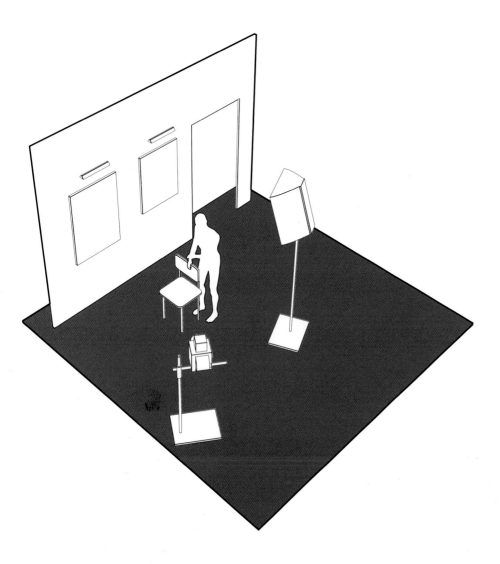

plan view

102

roy dotrice

This picture of the actor Roy Dotrice was taken in his extremely dark dining room. Why? Because the picture hanging up on the left-hand side was important to him since it related to a film he had appeared in, and he had asked if it could be included.

'I started by taking a reading from the light illuminating the picture,' says Leightley, 'which, although small, was surprisingly bright. I set up a flash head in a small softbox and placed it up high on the right-hand side. I needed a small aperture of f/16 to keep both the subject and the background in focus, so I "dragged" the shutter by setting a speed of 1 second.' The finished portrait retains the mood of the room, but the subject is perfectly lit.

- Mark Leightley
- Personal project
- Exhibition and book
- 6 x 6cm
- 60mm
- Kodak 1000
- 1 second at f/16
- Ambient light and flash

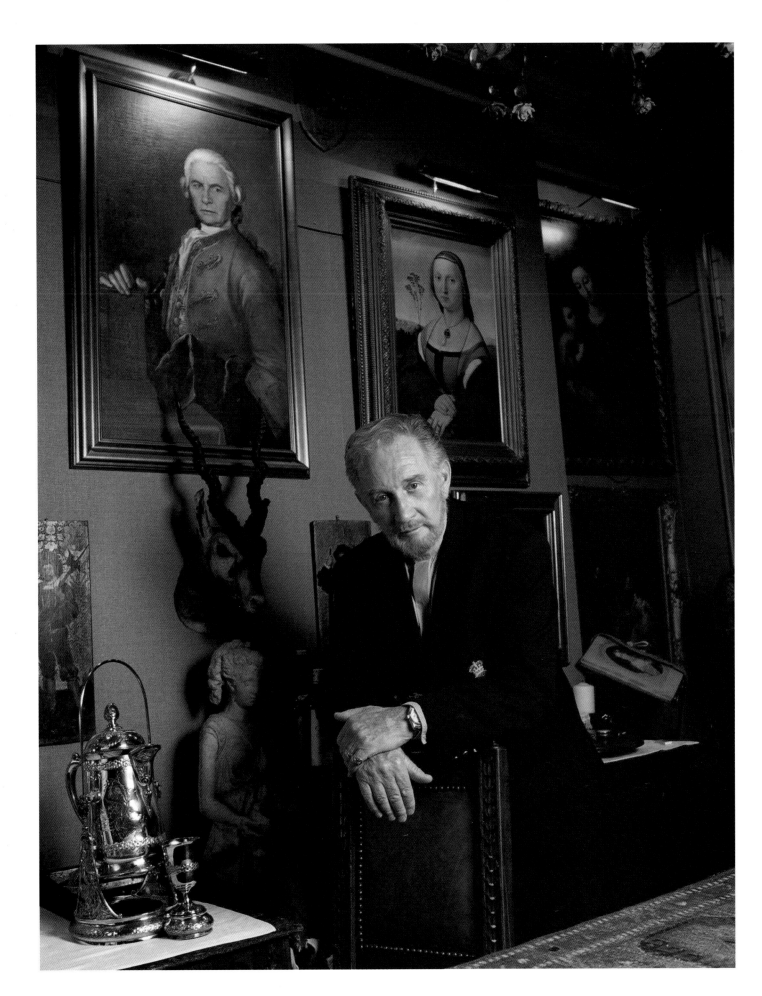

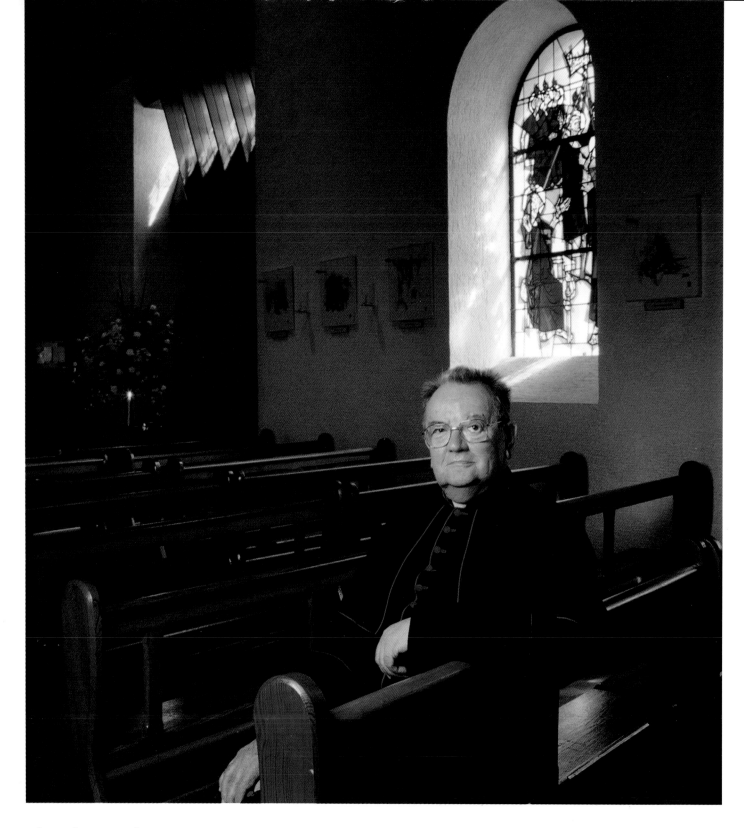

church portrait

This contextual portrait shows just how effective combining flash with the existing lighting can be. The photograph belies how extremely dark the church was. There were just a few strategically placed tungsten spotlights piercing the gloom, and a limited amount of light was streaming in from the stained glass windows.

Having carefully positioned his subject, Mark Leightley set up a small softbox towards the left of the camera, with a 6 x 4ft reflector on the right to provide fill. 'I was also anxious to include this tiny but for me important element – the single candle at the back of the church. Therefore I set a shutter speed of 1 second – sufficient to scoop up the available light.' The tungsten modelling lamp of the flash head had to be turned off just before the picture was taken, otherwise its output would have affected the exposure.

Mark Leightley
Personal project
Exhibition and book
6 x 6cm
60mm
Kodak 1000
1 second at f/11
Ambient light and flash

candlelight

When you're introducing your own lighting to the composition, you don't have to be limited by flash and tungsten heads. Here, it was half a dozen candles, which Leightley brought along to illuminate this portrait – in order to complement the weak light coming in from the tiny window on the right. Once the candles were burning well they gave out a surprising amount of light – allowing an exposure of 1/2sec at f/16. Leightley tried using a reflector, but found there was little or nothing to reflect.

 Mark Leightley
Personal project
Exhibition and book
6 x 6cm
60mm
Kodak 400
1/2sec at f/16
Ambient light

outdoor fill

This classic portrait looks comparatively straightforward – a burst of fill-in flash to balance against the light of the building in the background? – but it is, in fact, more complex.

Leightley explains: 'I waited until it was dusk, so the sky hadn't actually gone dark – this gave that important triangle of colour at the top of the picture. However, by that time the front of the building had gone dark, so I illuminated it by setting up a flash head behind the tree to give the barest output. The head was fitted with a blue gel to tone down the brilliant white of the doors, which could have potentially been distracting. The subject was lit by a small softbox at 45 degrees to the left of the camera, with a gold reflector on the right bouncing light back in. I measured the shutter speed by taking an ambient light reading inside the building and a flash reading from the subject and the front of the building.'

 Mark Leightley
Personal project
Exhibition and book
6 x 6cm
60mm
Kodak 400
1/2sec at f/16
Ambient light and flash

plan view

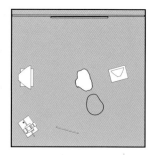

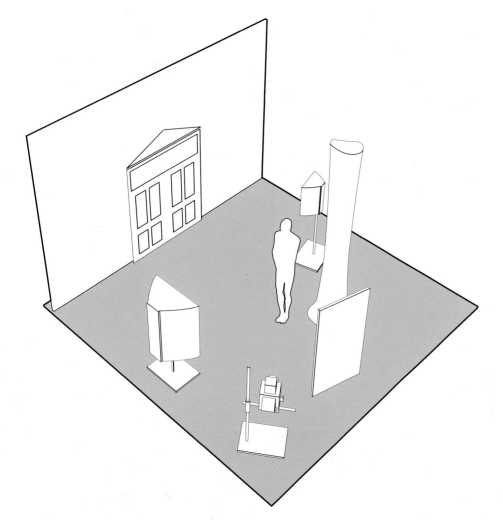

dressing room

Showing people in their natural setting is a great way of producing a satisfying and informative portrait. With a guitarist such as Peter Frampton, where better than a dressing room? However, when Leightley turned up, he found there were dirty magnolia walls that looked as if they hadn't been painted for twenty years, and a large domed skylight that made the room look even more cold and shabby.

'It was essential that I warmed up the walls,' he says, 'so I started by switching on some table lamps in the room and positioning them in the best location. Then I switched on the make-up lights, which helped create much more of a mood and illuminated the walls nicely. The lighting on the subject comes from a small softbox to the left. I balanced the exposure so the make-up lights burnt out to white, making them appear bright and sparkly, rather than as just dull and glowing.'

points of view

'When I want to give subjects an air of authority I use a low camera angle – and as he was the highest ranking Police Officer at the time, it seemed appropriate.'

107

two lights

This glamorous portrait for FHM magazine was taken using a couple of 'Kino' lights – these flicker-free 4ft fluorescent tubes are balanced for daylight and come in a unit that contains four tubes. 'They produce a different kind of light,' Dunas explains, 'and like any other tool, they're ideal for certain situations but not others. I like long exposure light sources such as these and tungsten because you get a creamy quality to the skin when you don't have the momentary blast of light inherent to flash.'

Given the glorious tones in this image, there's no arguing with that. However, considering there are eight tubes, light levels are surprisingly low. With both units less than 1/2m either side of the camera, the exposure still didn't rise above 1/30sec at f/5.6.

It's also worth commenting on the pose and composition. You don't always need your subject to be looking at the camera, or even have their eyes open, for it to be a successful image.

- Jeff Dunas
- FHM magazine, UK
- Various
- 6 x 7cm
- 140mm
- Agfachrome 100
- 1/30sec at f/5.6
- Fluorescent tubes

plan view

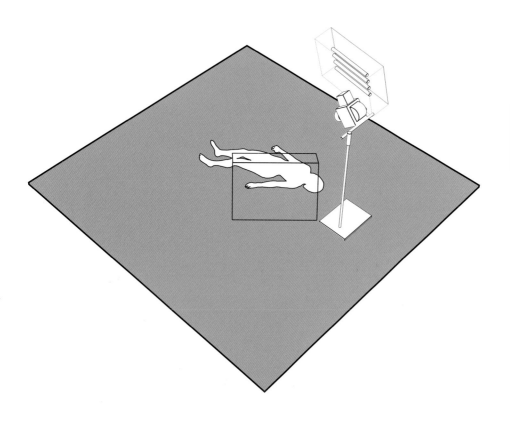

katherine heigl

Using specialised continuous light sources gives skin tones a creamy texture.

on fashion photography

'In the fashion world they use all kinds of ludicrous and gimmicky lighting to get readers looking at the frocks on the page,' says Dunas, 'but it's not about photography, and it's not what I do. For me it's the content that's important, and that's why I like to keep things simple on the technical front.'

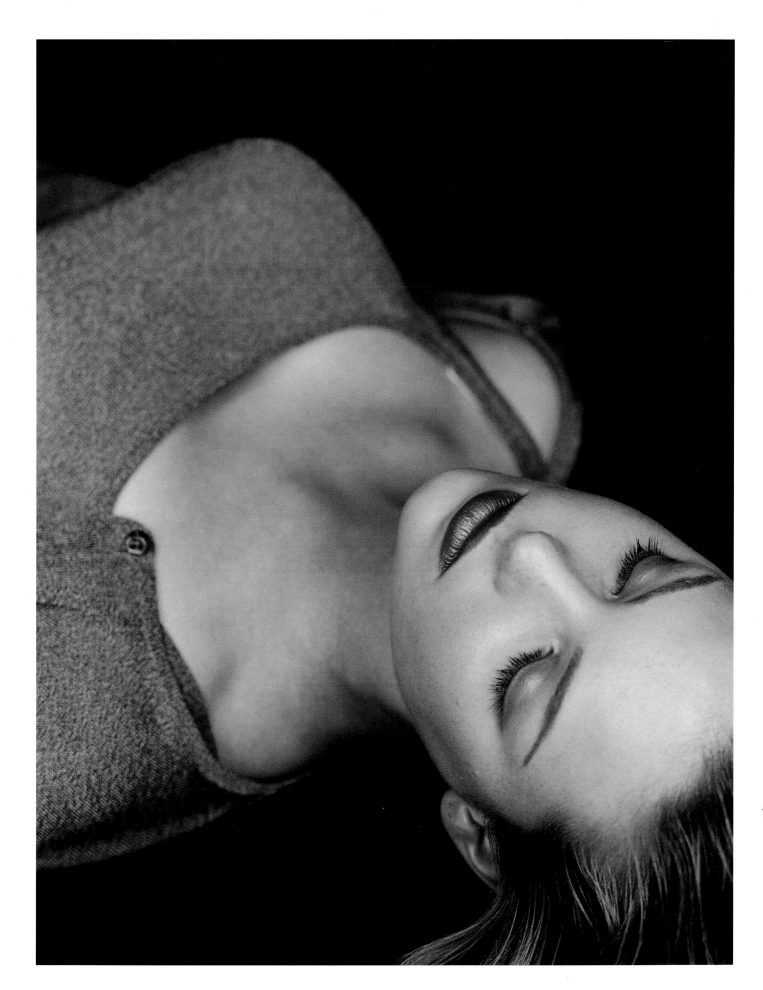

When most parents commission a portrait of their young daughter, they are seeking a traditional, pretty image. Others, though, are more open-minded, and appreciate a less conventional and more artistic treatment – like the one shown here.

'She was an extremely mature little girl for her age,' says photographer Tamara Peel. 'She could look straight through you, and that's what I wanted to show. I really love the eerie, haunting quality of the picture, accentuated by having the camera slightly above eye height and angled down.'

Peel likes to keep the lighting simple, so she used two studio flash heads fired into umbrellas placed at 45 degrees, with the child 1m in front of a plain white backdrop. To bleach out the skin tones the film was overexposed by two stops, and the negative was printed onto lith paper to enhance the result.

- Tamara Peel
- Private commission
- Album/wall portrait
- 35mm
- 35–70mm
- Fuji Neopan 400
- 1/60sec at f/11
- Electronic flash

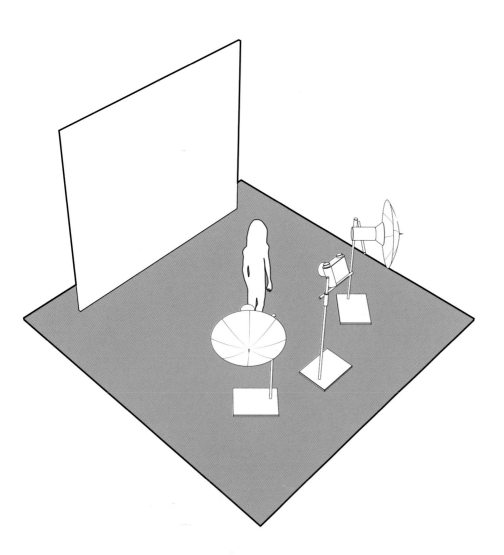

plan view

the eyes have it

112

Capturing the aspects of maturity in youth requires sympathetic and sensitive lighting.

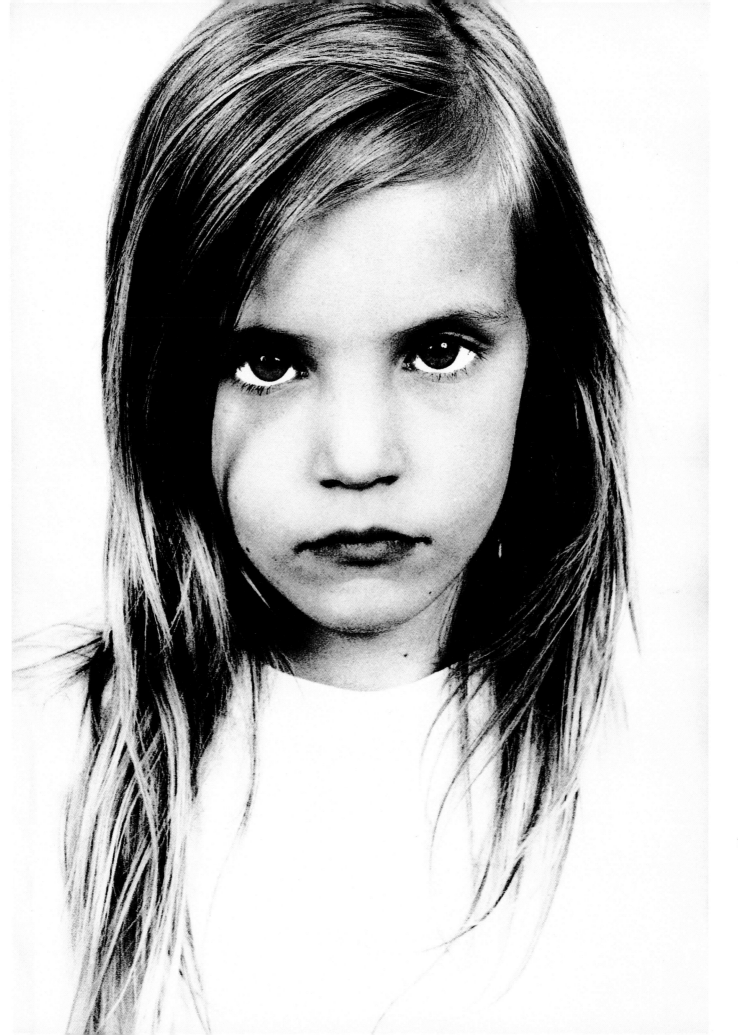

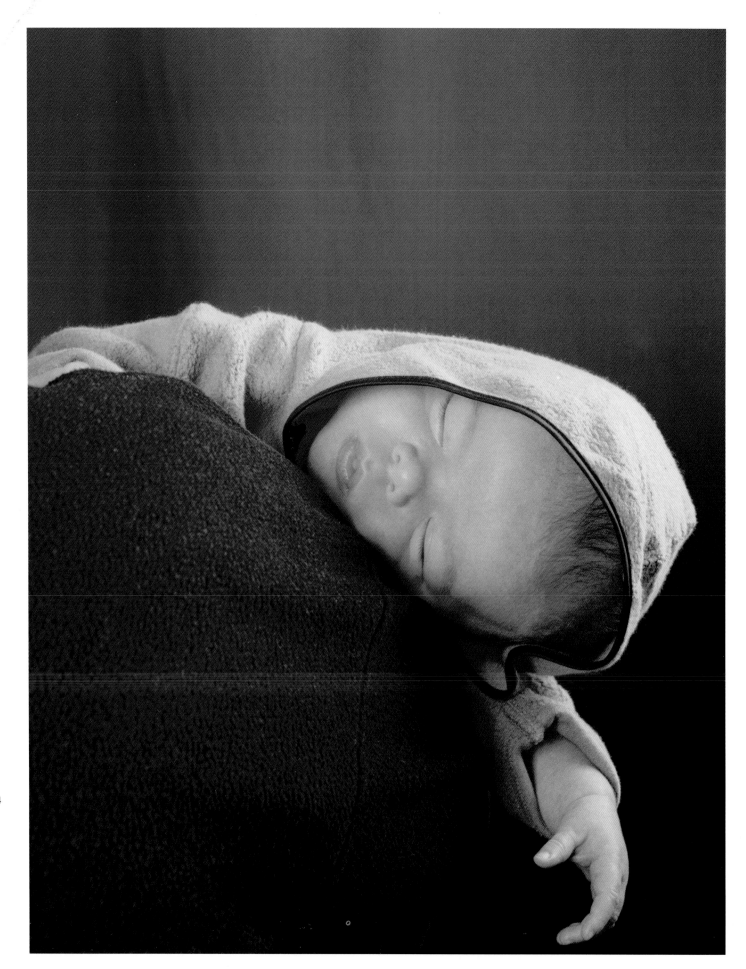

It's all very well setting up your lights carefully, but what happens if – as is often the case with children – your subject moves around a lot? It can be a problem, but sometimes the subject's unexpected positioning can produce attractive results which you hadn't planned.

In this image, for instance, photographer Karen Parker set up the lights in a relatively standard way, with one softbox placed each side at 45 degrees for even lighting. However, in the course of the session the subject moved slightly more towards one of the lights than the other, and away from the angle on the background intended. Noticing this engaging expression, Parker quickly grabbed a shot or two, even though the lighting wasn't as she'd intended. The result, though, is refreshingly different.

- Karen Parker
- Personal project
- Portfolio
- 6 x 7cm
- 110mm
- Agfacolor 100
- 1/60sec at f/11
- Electronic flash

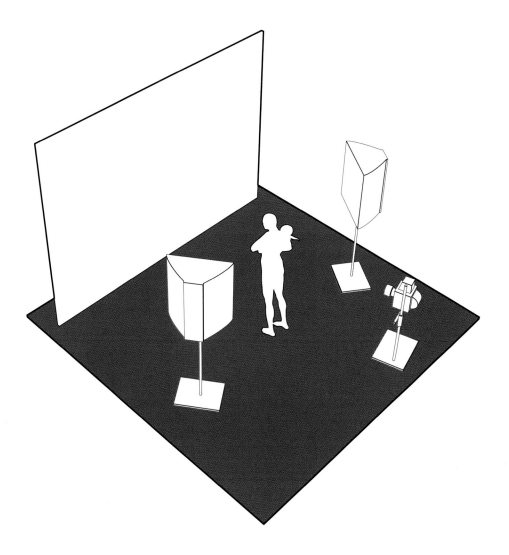

plan view

sleeping baby

Unconventional lighting can result from grabbing a shot at an unexpected angle.

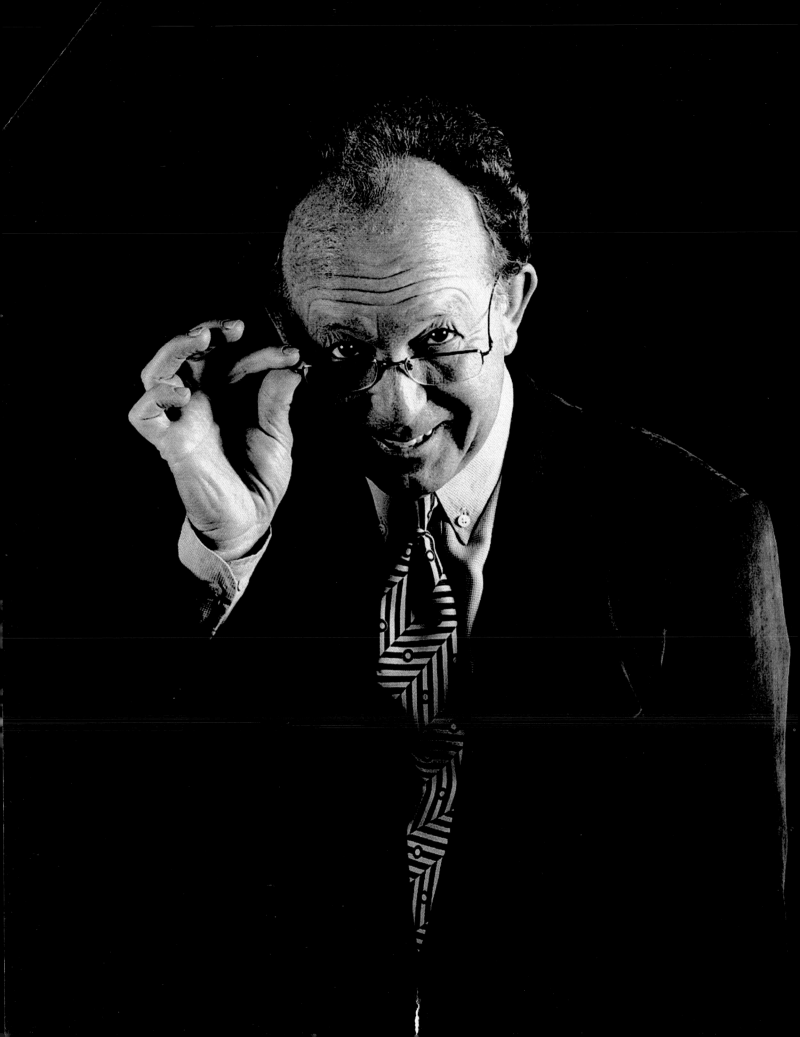

These pictures were taken for a series of advertisements for an opticians – and naturally all of the people shown are wearing glasses. For that reason photographer Karen Parker placed the lights higher than usual, to minimise the risk of distracting reflection.

Since the advertisements were appearing in newsprint, she wanted a strong, punchy, graphic image; and so positioned two softboxes farther round to the side than she would normally have done. The softbox from the left was set to a weaker output just to fill in the shadows on this side. A folding triple reflector angled underneath the subject ensures that the whole face doesn't go too dark.

🚶	Karen Parker
🔄	Hammond & Dummer opticians
🏷️	Advertisement
📷	6 x 7cm
🔘	110mm
🎞️	Agfapan 100
⏱️	1/60sec at f/11
💡	Two softboxes

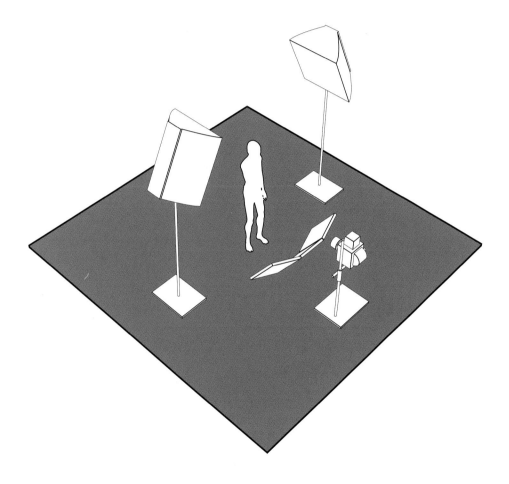

plan view

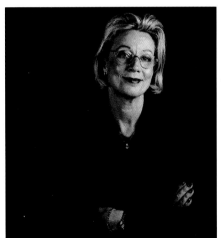

optical shots

Photographing people wearing glasses requires a high lighting position.

environmental portraits

The editorial approach of Dennis Schoenberg

Some portrait photographers go into a session with relatively fixed ideas about what they want to do – but Dennis Schoenberg is not among that number. 'I always ask the people I'm going to photograph how they would like to be presented, and whenever possible I incorporate their views into what I do. Working together with someone, and being able to show them in their own light, is very much my preferred way of working.'

Shooting largely for editorial use, Schoenberg takes an environmental approach to his subjects, almost always showing them in their common surroundings. 'I really dislike studio work, where the person is cut off from the real world. It's very difficult to judge a person solely on the basis of what they look like and what they're wearing. It's nicer for the viewer to see them in a situation that tells you about them, which is why I strongly prefer

to shoot on location – using a real-life background that tells you more about the person. In many ways my shots are very simple, but I really like that straightforward kind of aesthetic. It's also practical, as often you only have no more than 15 minutes with the person.'

plan view

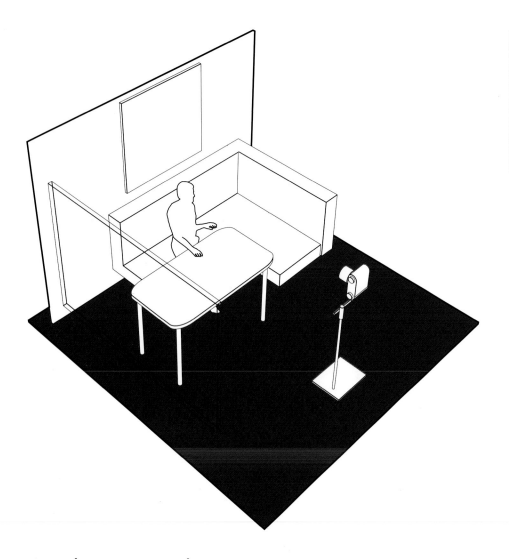

cowboy artwork

Most portrait photographers organise their compositions so as to concentrate attention on the subject, but here quite the opposite approach has been followed. By placing the person, dressed all in black, in front of an enormous piece of bright artwork, a dynamic tension has been established between the subject and his surroundings. 'The cowboy painting hangs in a restaurant in London and is by one of my favourite artists,' says Schoenberg. 'I knew one day I would photograph someone in front of it, and when I was asked to photograph this fashion designer it just seemed right.'

'The lighting for the picture is entirely natural – which is unusual for me – and comes from a huge window over on the left-hand side. It was a fairly sunny day, and there was plenty of light bouncing around.'

- ⊛ Dennis Schoenberg
- ⊜ i-D magazine, UK
- ⊛ Editorial
- ⊛ 35mm
- ⊛ 28mm
- ⊛ Kodak T-400CN
- ⊙ 1/30sec at f/5.6
- ⊙ Ambient light

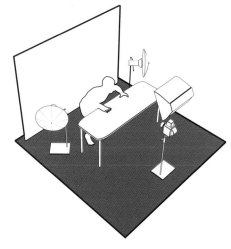

buckwheat grass

One of the best ways of breathing life into a picture is to get the subject to move about or interact with their environment. 'I just asked the guy to mess around,' says Schoenberg, 'and photographed him when something interesting seemed to be happening.'

Because the background was equally important, it was lit separately by means of two studio heads fired into umbrellas at 45 degrees. A single softbox over the top of the camera illuminated the main subject. Lots of test Polaroids were taken to ensure the balance of the exposure was just right.

- Dennis Schoenberg
- i-D magazine, UK
- Editorial
- 6 x 7cm
- 90mm
- Fujicolor 100
- 1/60sec at f/8
- Electronic flash and softbox

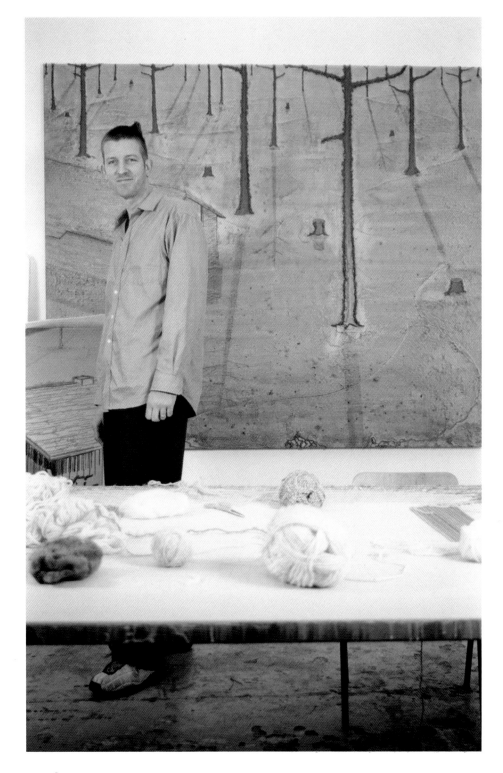

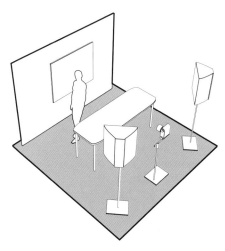

painter

'You see a lot of bland photographs of painters standing in front of their paintings,' says Schoenberg, 'and I wanted to do something a little more interesting.'

He introduced a table in the lower third of the frame, which included elements used in the making of the artwork. The table was rendered out of focus and allowed to overexpose. This created a strong sense of depth as well as providing a narrative.

Since the painting was an important part of the shot, two softboxes were evenly placed 2m either side of the photographer, fairly high up.

 Dennis Schoenberg
i-D magazine, UK
Editorial
35mm
50mm
Fujicolor 100
1/30sec at f/16
Two softboxes

One of the easiest ways of changing the tonality of a white background is to not light it directly – only your subject. In this way it's the light that spills behind the subject which determines how bright or dark the backdrop is – and that can be regulated by how far it is placed behind the model and by the nature of the lighting. Cross-processing, though, adds another dimension to this equation – as in these images, where it transforms an unlit white paper roll with a rich blue-green tone.

This effect was not simply a matter of chance: photographer Karim Ramzi deliberately placed the background 3m behind the subject, and used just two lights close to the camera. Ramzi explains: 'The main light is a small softbox over the camera. However, with cross-processing the contrast is high, so below the softbox I used a second light with a white reflector to soften the shadows.' The result of all this is a bold, vivid portrait bursting with colour and detail.

Karim Ramzi
Authentic Panama
Catalogue
6 x 7cm
150mm
Kodak E-100S (cross-processed)
1/500sec at f/11
Electronic flash and softbox

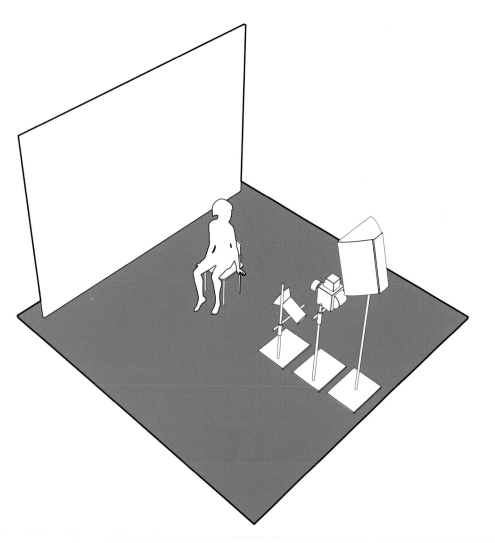

plan view

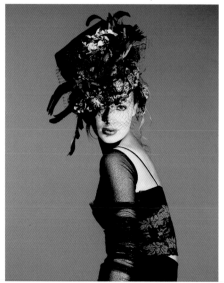

floral portrait

122

Lighting and processing options offer bright, vivid colours.

This is a more traditional take on the subject, taken during the same shoot.

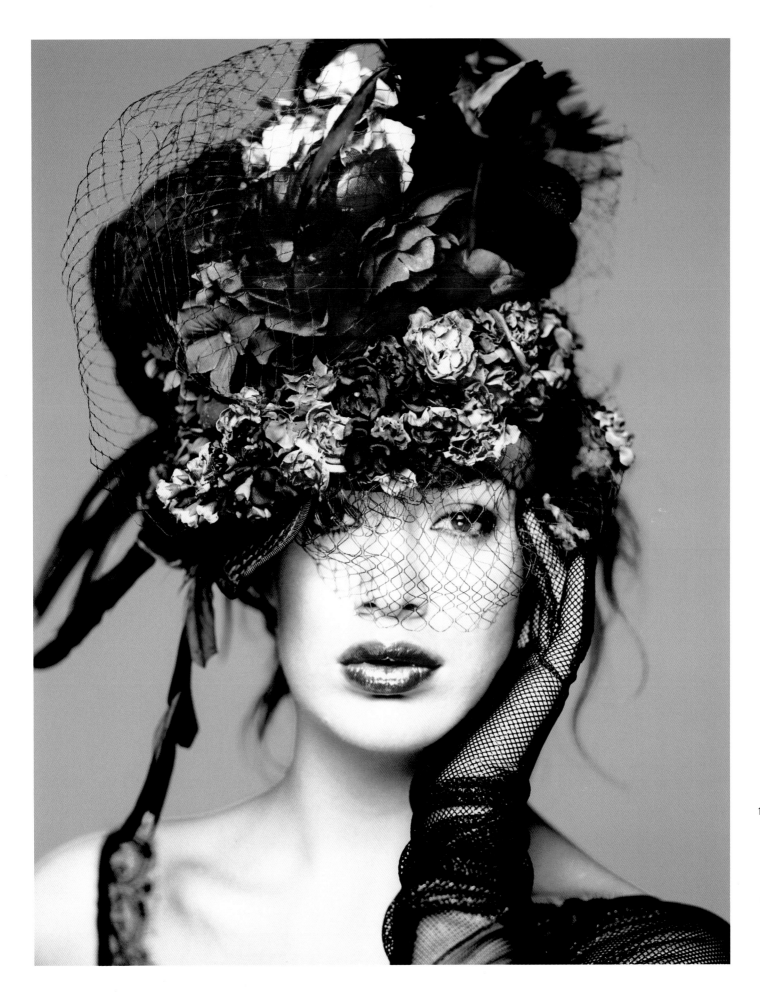

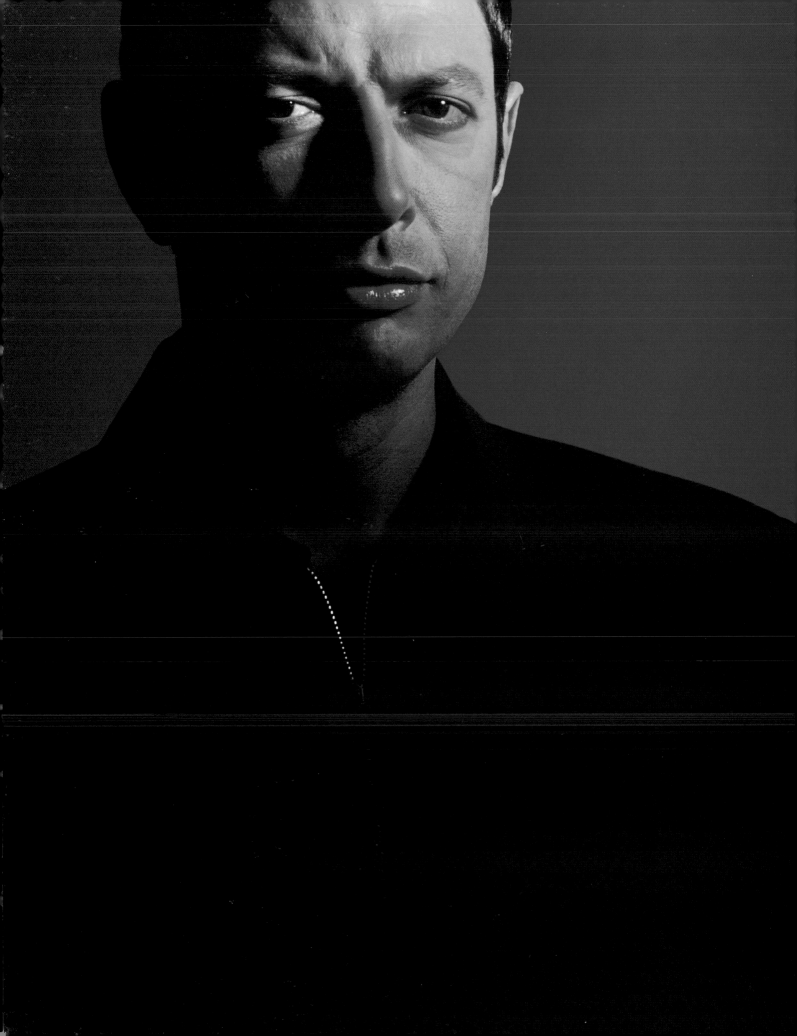

more complex set-ups

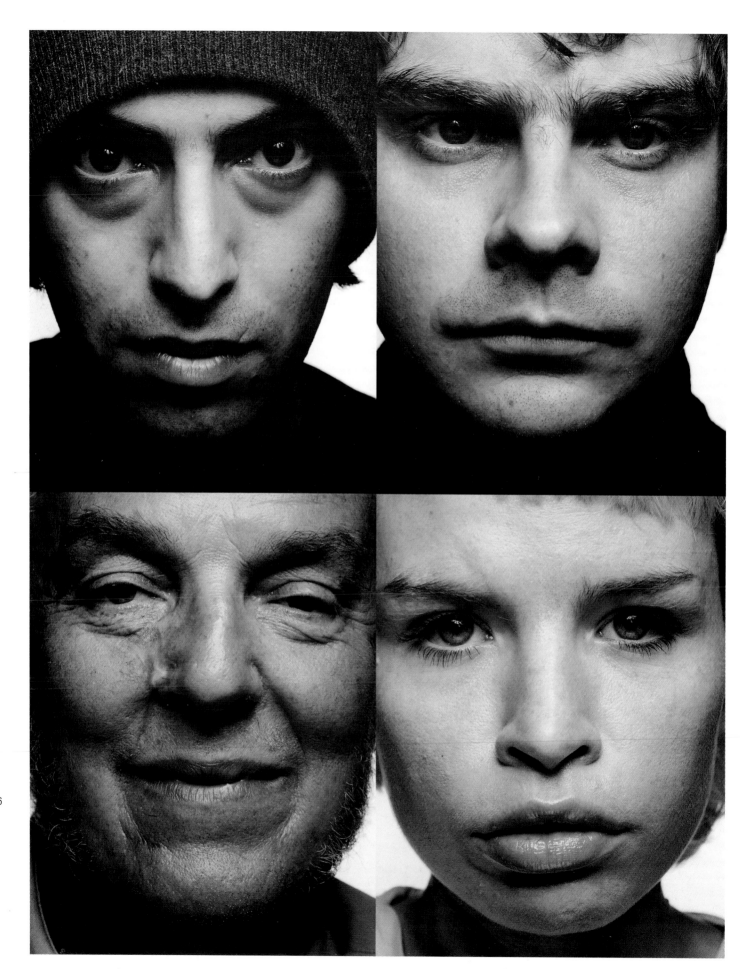

A war photographer once famously said, 'If your pictures aren't good enough you're not close enough.' This is not a criticism that can be levelled at these portraits, which are cropped extremely tight, so that the tops of the heads and the ears are out of frame. This was achieved using a 360mm lens on a 10 x 8 inch camera – the telephoto focal length minimising facial distortion and allowing the camera to be kept at an acceptable distance from the subject. The large format produces images with exceptional clarity – and this is enhanced by the choice of lighting.

'With this set of images I wanted to get the personality of each individual naturally,' says Hiroshi Kutomi. 'I focused just on the face without the need for any image helpers such as hair stylists.'

In each case the subject is sitting, and two flash heads have been used. The main light, fired into a brolly, is over the top of the camera; while the second, a softbox, is below it. Large black polystyrene boards on each side of the subject create the shadowed edge to the face. Although little of the background can be seen, it was in fact lit by means of heads, with output set to produce a clean, crisp white.

- Hiroshi Kutomi
- i-D magazine, UK
- Editorial
- 10 x 8 inch
- 360mm
- Polaroid 804
- 1/125sec at f/45
- Electronic flash and softbox

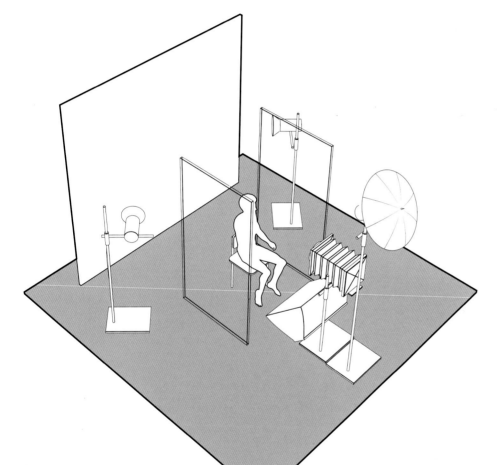

plan view

character close-ups

Go in close for maximum impact – but light carefully.

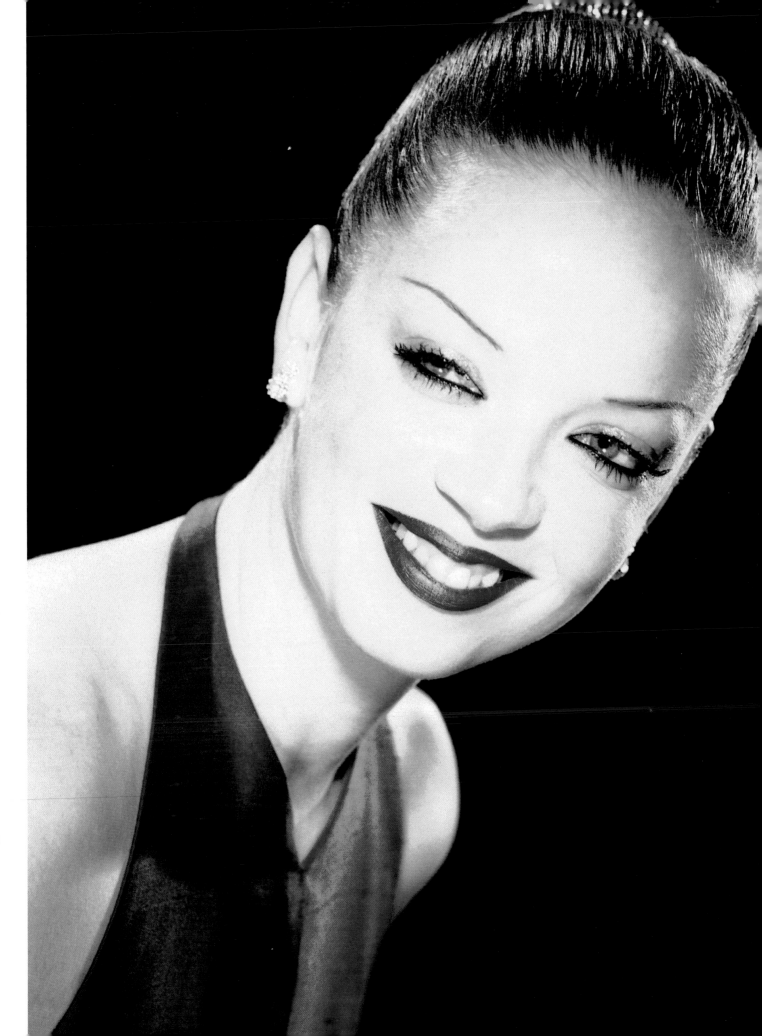

If you want your pictures to stand out from the crowd, you need to try something different. Here, the photographer has combined a 'Hollywood' lighting technique with an unusual film choice to produce an image that is at the same time contemporary and traditional.

Three flash heads were used, all fitted with snoots to concentrate and limit the light. Two providing the backlighting were set at about 45 degrees behind the subject, with the third directly above camera. This was also then supplemented by a foil bounce board underneath the lens.

'I was after that faded colour dye effect that you get with older emulsion,' says Dave Willis, 'so that the shot looked like it was older than it was – as if it was taken in the 1950s or '60s. By using the wrong film for the job – a tungsten-balanced emulsion with flash – I got a nice blue cast, which was just what I was after.'

Dave Willis
Kerrang! magazine, UK
Editorial
6 x 7cm
180mm
Fujichrome 64T
1/60sec at f/5.6
Electronic flash

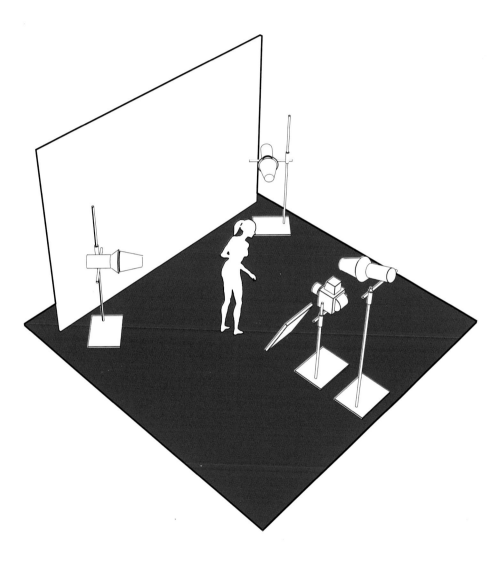

plan view

shirley manson

Don't be afraid to break the rules to produce something original.

jackie o

Using two softboxes close together gives incredibly soft beauty lighting.

- Erwin Olaf
- Personal project
- Portfolio
- 6 x 6cm
- 50mm
- Kodak E100S
- 1/500sec at f/8
- Electronic flash and two softboxes

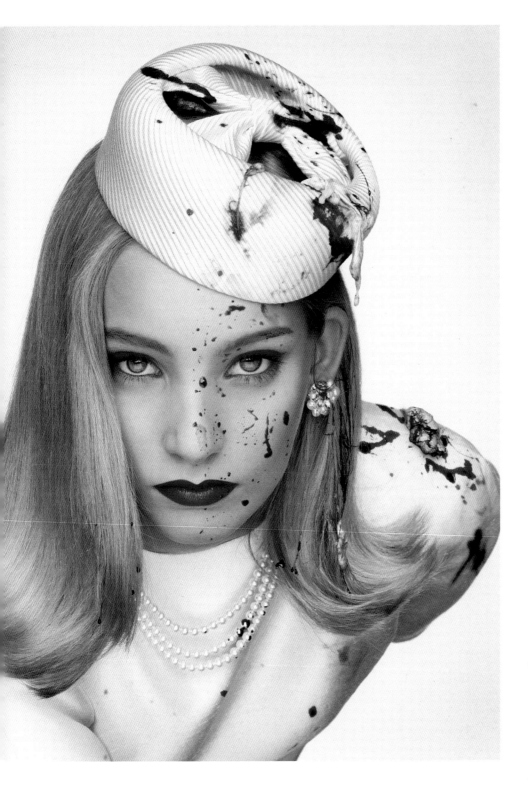

How many differences can you spot between these two images? – the blood, obviously, intended to illustrate the dramatic and incongruous change in Jackie O's appearance when her husband was assassinated. In fact there are also several others – including changes to the eyes, nose and mouth – all carried out using a computer. 40 per cent of the colour has been removed, and the contrast increased.

However, it's the quality of the lighting that really stands out. When using a standard 'beauty' set-up, the effect can be carefully controlled by how close together the two softboxes are placed in front of the subject. To achieve this degree of softness they were almost touching – just 20cm apart – with just enough room for the lens to poke through the slit in between. The softboxes themselves are only 50cm away from the model. The perfectly white background was evenly lit by a pair of heads on each side fitted with 12 inch reflectors. To produce a flattering perspective, the camera was positioned above the subject, who was leaning towards it.

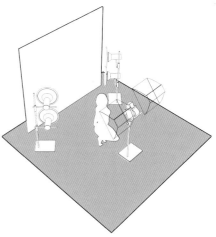

plan view

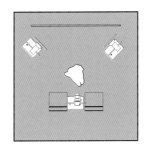

'I had two hours with actor Jeff Goldblum,' says Dunas, 'but in that time I had to do enough photography to fill eight pages. Generally you have a lot to shoot in the time available, so I plan all my pictures ahead of time, and have the lights arranged before the subject gets here. On this occasion we had four set-ups ready to roll, and were able to move fluidly from one to the other. That's important, because then I can keep the attention of the subject riveted on what I need, and nothing is left to chance. You don't want to give them the opportunity to fall back into thinking about their own life or wonder what they're going to do later, because then you've lost it.'

This picture was taken using an interesting and original technique. The vivid blue was produced by fitting a blue filter over the lens. The white studio was flooded with light by bouncing two flash heads off the ceiling. Goldblum was then lit by just one head fitted with a grid spot to concentrate the light, and an orange gel to compensate for most of the blue of the filter.

Jeff Dunas
Venice magazine, USA
Various
6 x 7cm
90mm
Agfachrome 100
1/500sec at f/8
Electronic flash

plan view

jeff goldblum

Using a compensating lens and camera gels helps produce vivid colours.

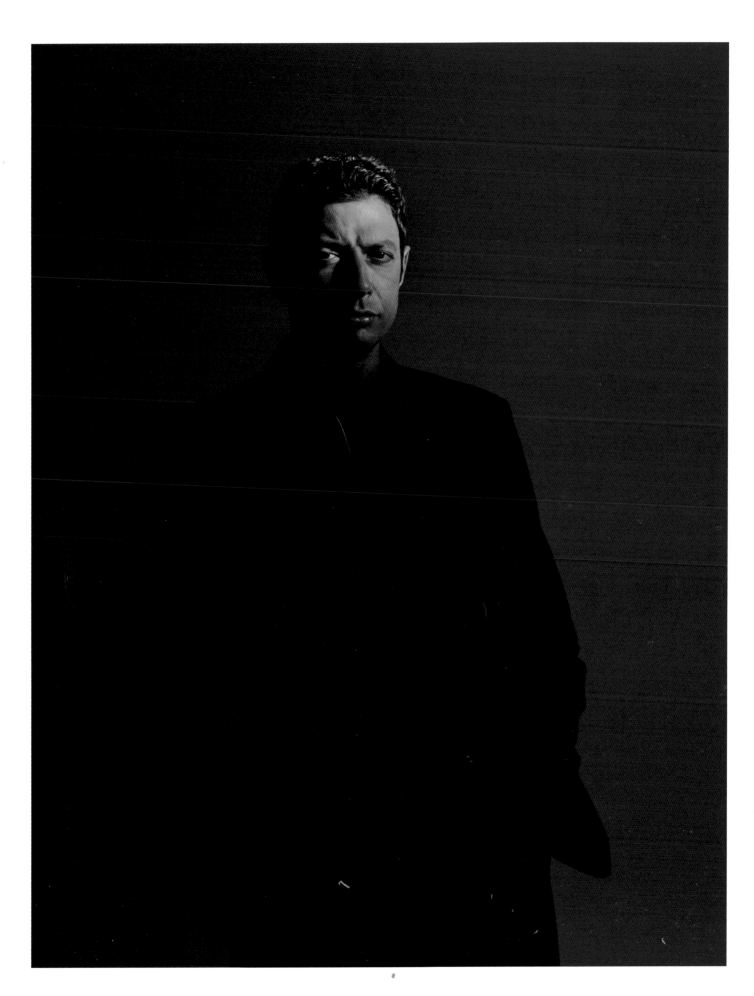

133

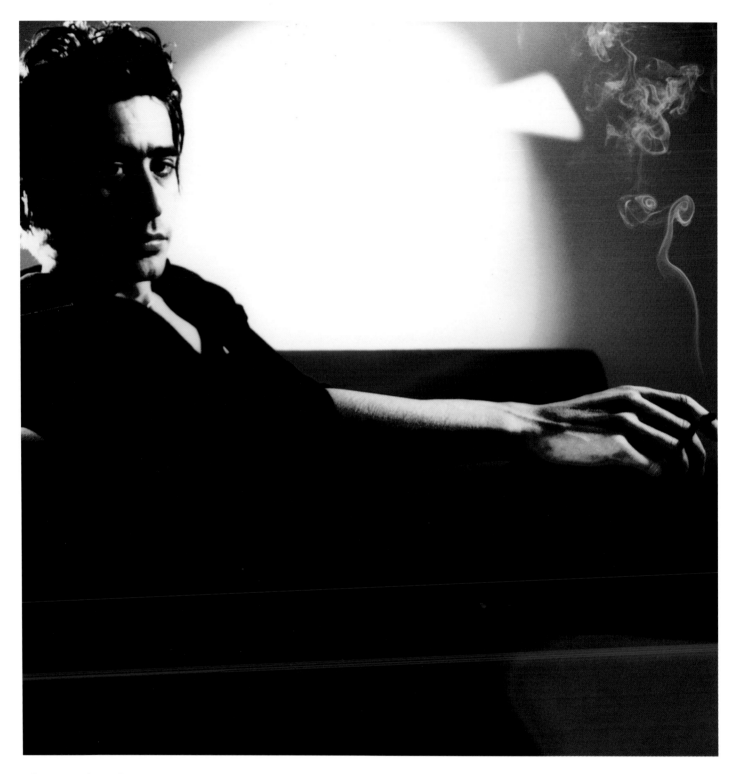

theatrical spot

Don't just use the same old set-ups – be imaginative, experiment!

Simple lighting doesn't have to be boring, providing you're willing to take a few risks. Only three heads were employed for this picture, but the effect is considerably more dramatic than a normal configuration would give.

What catches your eye immediately is the large circle at the back, similar to the spotlight effect you sometimes see in a theatre. This was created quickly and easily by mounting a snooted head on a floor stand behind the seating.

The lighting for the subject comes from two units: a head in a standard dish on the right-hand side and a snooted head to the left which backlights the hair. The stray triangle, by the way, was not intentional at all, and was the result of surprisingly strong stray ambient light coming in through a skylight.

 Dave Willis
Headswim (pop group)
Publicity shot
6 x 6cm
80mm
Fujichrome Astia (cross-processed)
1/60sec at f/11
Electronic flash

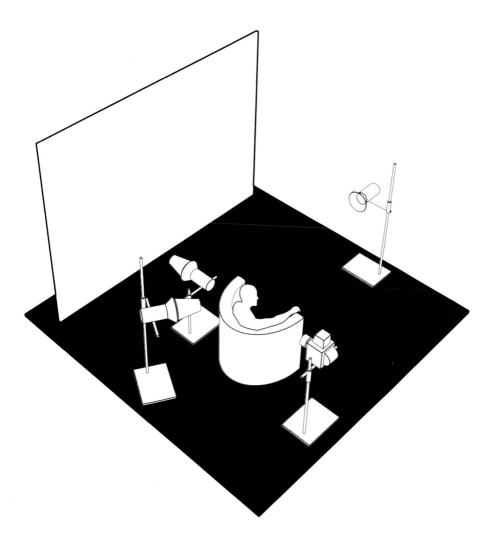

plan view

industrial plating

Using gels can help give shots an industrial feel.

Neil Warner
Irish Finishing Technology
Brochure
6 x 6cm
110mm
Fujichrome Provia
1/500sec at f/8
Electronic flash

One of the simplest ways of giving corporate portraits an 'industrial' feel is to use gels over your lights. Pretty much any colour can be used, but pink and purple are extremely popular, and seem to work well in combination.

A head with a blue gel was placed behind the subject, facing the wall 2m behind, from where it reflected back onto the metal plates in the foreground. There are two lights with pink gels. One is to the left of the photographer, slightly above eye height, in a 12 inch reflector that allows some of the light to spill onto the background. The second is a snooted head to the left near the subject's shoulder, lighting his neck and gloves.

It's important when you're working with gels that at least part of the subject is lit with white light – providing a counterpoint to the richness of the gels. Here there's a head in a 12 inch reflector off to the right, fitted with barn doors to control exactly where the light falls.

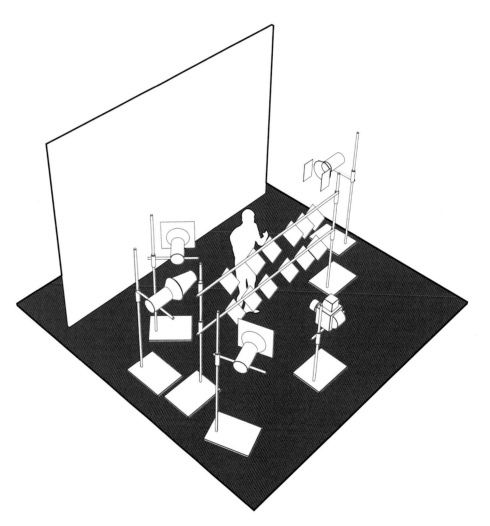

plan view

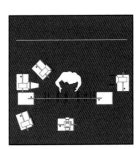

There's nothing to beat concentrating on the face with a close-up when a subject's appearance is really characterful. The lighting here is as straightforward as it is effective. The main illumination comes from a snoot just above the camera, with a reflector board placed below it to soften the shadows. The accents on the head come from two snooted lights that were set at about 45 degrees behind the subject. Getting the person to lean into the camera, and using an aperture of f/5.6, helps separate the head from the rest of the body.

- Dave Willis
- Private commission
- Publicity shot
- 6 x 7cm
- 180mm
- Fujichrome Astia (cross-processed)
- 1/60sec at f/5.6
- Electronic flash

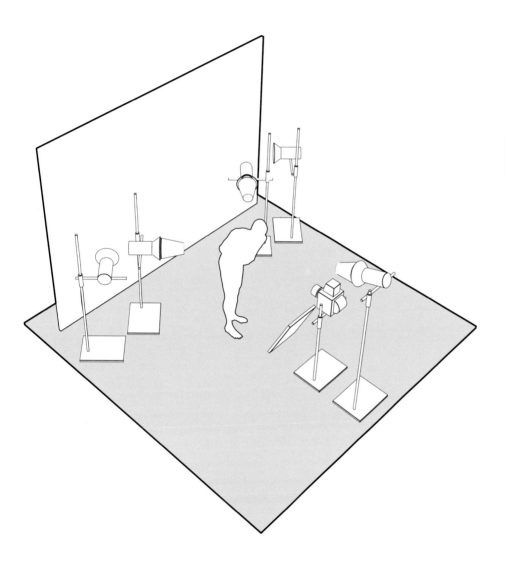

plan view

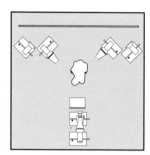

publicity shot

Go in close when your subject has lots of character.

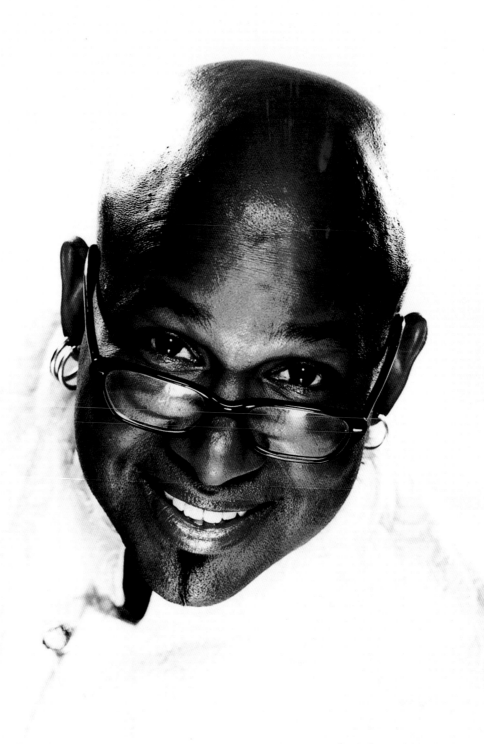

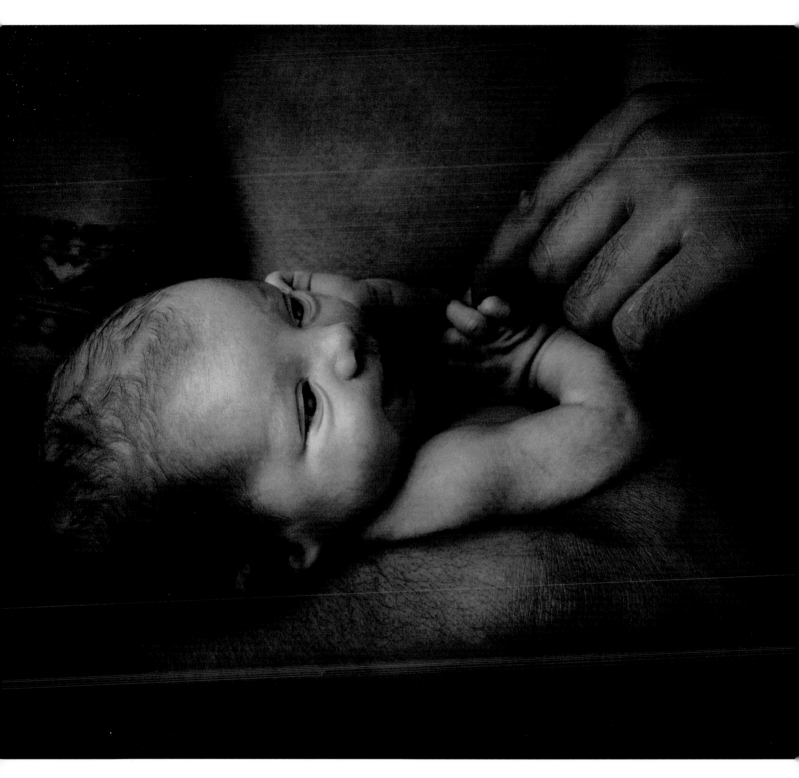

cradled baby

Timeless images require sensitive lighting if they're to avoid looking dated.

Contrasting small and large and young and old is always a sure-fire way of coming up with a winner – and especially so when the baby is so tiny and the adult so huge. Sympathetic lighting and skilful printing, though, have made all the difference here. The subjects are totally encased in a semi-circular light tent made from sailcloth material, and three lights have been stacked to the left – at knee, waist and head level, producing a sumptuously soft illumination. No additional reflectors were needed, as the material itself acted as a fabulous wraparound reflector.

During printing the baby was lightened in relation to the background subject and, the image having been scanned, the smile was exaggerated using Adobe Photoshop, and the catchlight in the eyes improved.

⚇	William Long
⚇	Personal project
⚇	Personal
⚇	6 x 7cm
⚇	110mm
⚇	Kodak T-Max 100
⚇	1/125sec at f/11
⚇	Electronic flash

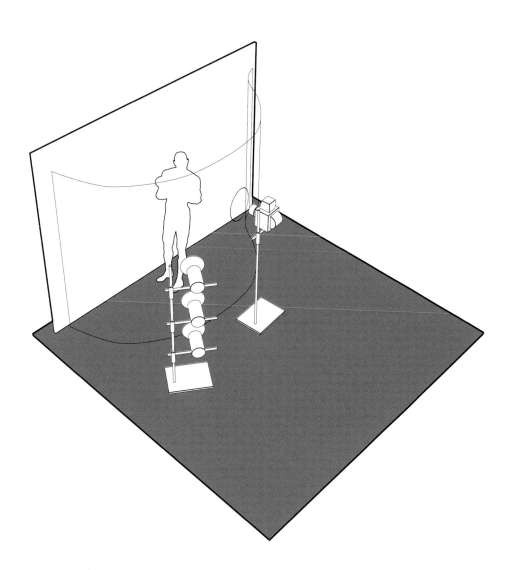

plan view

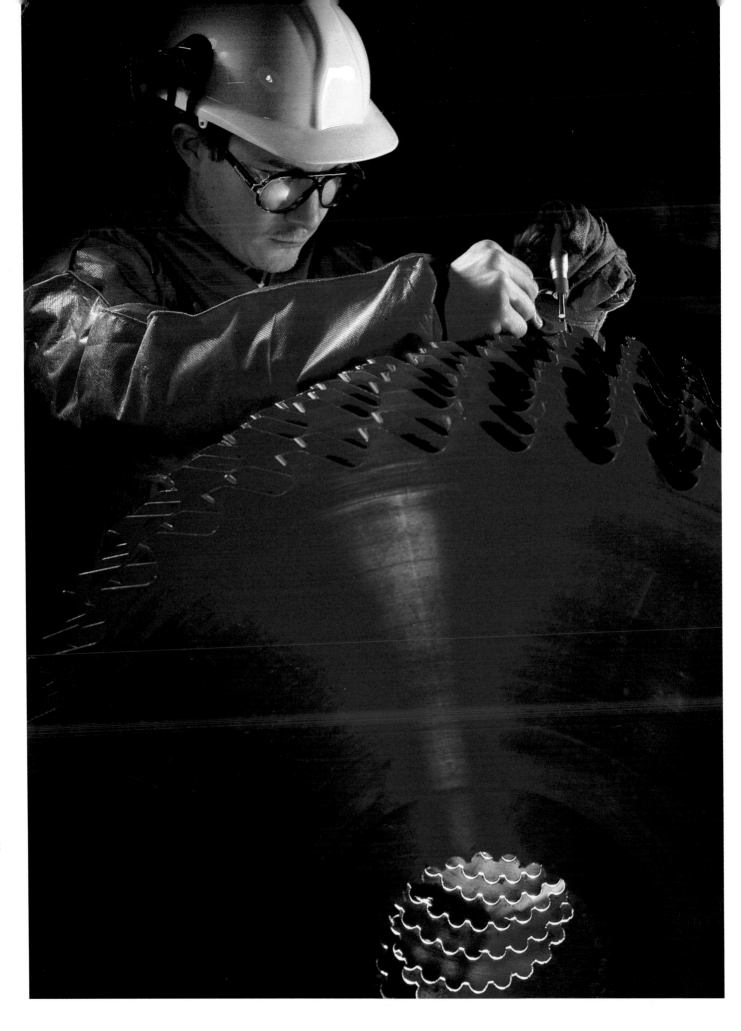

When shooting on location in an industrial setting, lighting needs to be carefully controlled – so that subjects can be isolated from potentially distracting backgrounds.

In this photograph the main light is coming from a flash head in a 12 inch reflector over to the right-hand side. It is supplemented by a reflector on the left-hand side, while the texture of the arm is revealed by a snooted head just behind the shoulder on the left.

Thoughtful lighting of any materials being employed is also important, and here two lights have been used. A bare head was fired through the middle of the saw blades to reveal the teeth, while a head fitted with a purple gel to the left of the photographer adds much needed colour and contrast to the shot.

 Neil Warner
ECC Sawmills
Brochure
6 x 6cm
110mm
Fujichrome Provia
1/500sec at f/11
Electronic flash

plan view

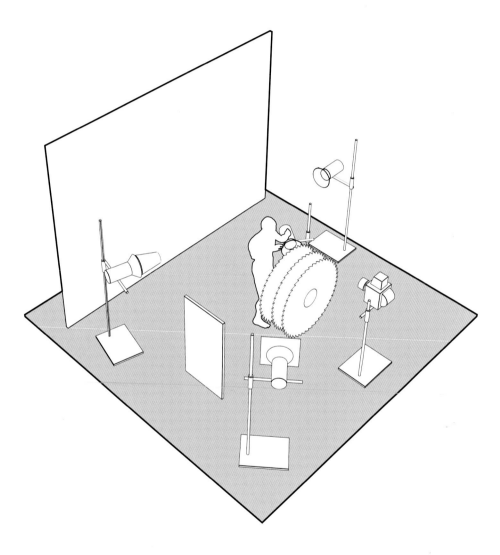

man with saw

Lighting your subjects carefully can help isolate them from distracting backgrounds.

'Australia has a lot of illegal immigrants,' says Long. 'Most come from ravaged nations close to our country, and I wanted to interpret and convey that sense of despair at such unrest. I had some wire mesh, and I just started to experiment.'

Part of that experimentation involved trying out different lighting set-ups, with the final image illuminated with five bare flash heads directed through a white screen to give an overall diffuse but directional light. Skilled, sepia-toned printing by the photographer brought out the whites of the eyes and darkened down the edges of the print. This, with the direct, unblinking gaze of the subject, and tight cropping, results in a compelling and powerful portrait.

William Long
Personal project
Various
6 x 7cm
180mm
Kodak T-Max
1/125sec at f/16
Electronic flash

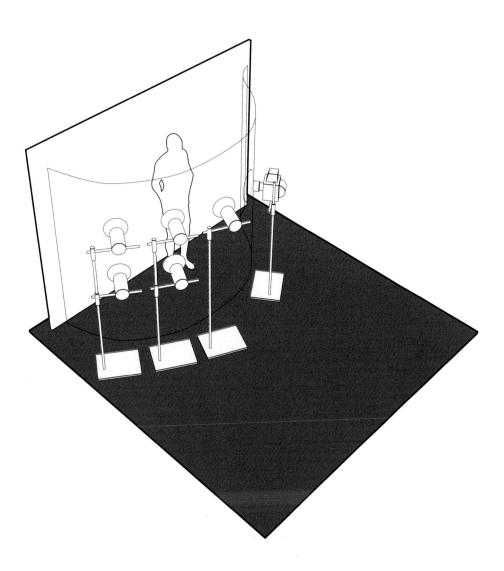

plan view

face under wire

144

Imaginative lighting and consummate printing result in a compelling portrait.

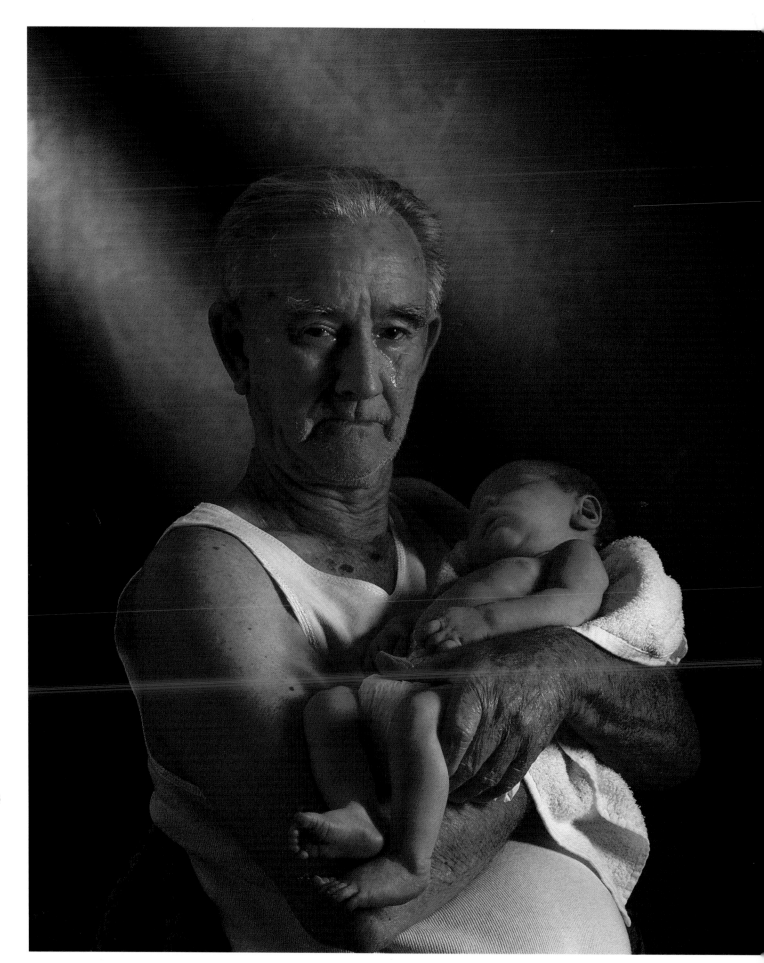

Although initially self-researched and self-commissioned, this image was intended to be used as a fund-raising gift for SIDS (Sudden Infant Death Syndrome). They loved the image and it was used as planned – including in their Annual Report.

'The main points I was trying to convey were the passing of time, the generation gap, and the fact that the effect SIDS has on grandparents is often overlooked,' Long explains. 'I wanted a grungy, minimalist effect, so I used the bare concrete walls of the studio I was in at the time. The main light is a large softbox to the right, with a smaller softbox providing fill in from the left. I fired a third light fitted with a fine grid through a cut out to give the louvre effect on the background.'

The subject is actually the grandfather of the newborn baby, and the whole family, including the proud parents, had come straight from the hospital. The grandfather was conservative and shy, and had apparently never taken off his shirt in public before – yet was quite happy to do so for the picture when asked. 'Tears came naturally during the course of the shoot,' says Long, 'as a result of questions and conversation. I often chat to the subject, to distract them from the tension of being photographed.'

- ⚐ William Long
- ⊙ Personal project
- ⊕ Fundraising
- ⊕ 6 x 7cm
- ⊛ 110mm
- ⊡ Kodak Ektachrome
- ⊘ 1/125sec at f/11
- ⊙ Electronic flash and two softboxes

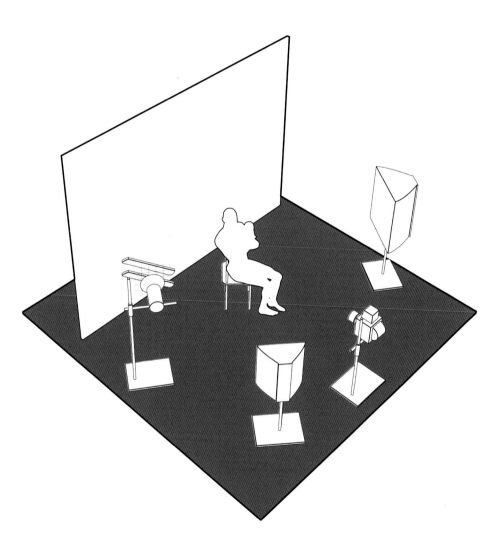

plan view

grandad with baby

147

A moving portrait across the generations receives sensitive handling.

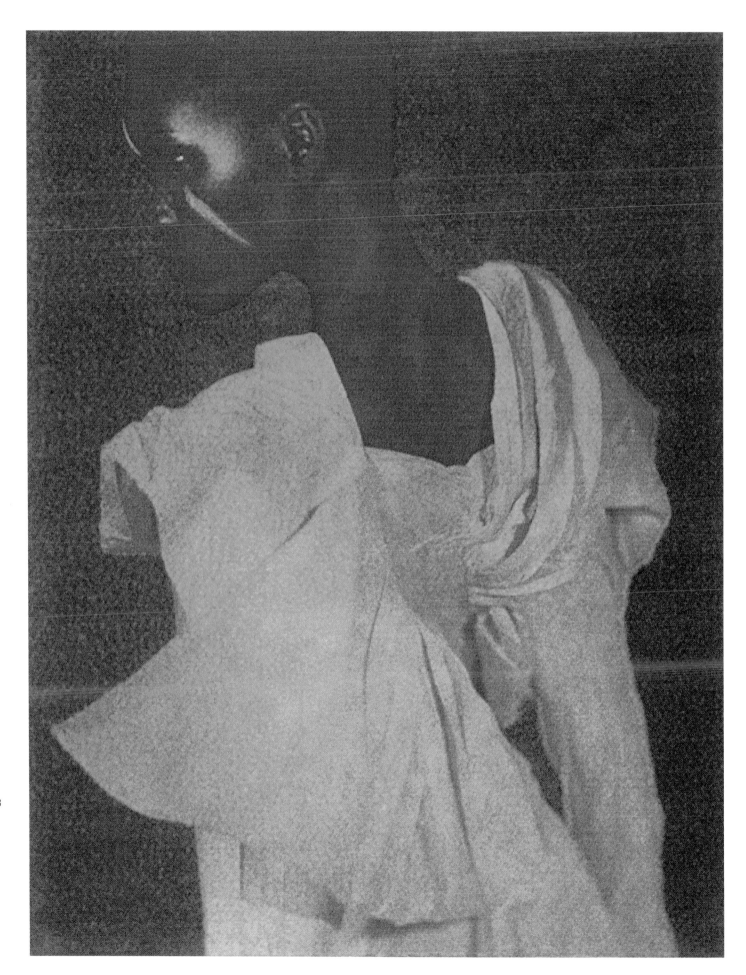

Canino uses continuous HMI lighting, typically employing around six heads to reveal the shape and texture of her subjects, and separating out the face and the body. She also places great importance on flags to control the direction of the light. 'I make pictures that are to be touched with the eyes,' she says. The background is lit separately, with red gels illuminating a red background to increase the intensity of the colour.

The pictures themselves were taken using the big Polaroid camera, of which there are only two in the world. The camera is the size of a wardrobe, and produces a 20 x 25 inch instant image. In this case, the image was then transferred onto 250gsm textured art paper.

ⓧ Patricia Canino
☉ Audrey magazine, Italy
◉ Editorial
▣ Polaroid 20 x 25 inch
◕ Standard
◐ Polaroid
◯ Not known
◯ Continuous HMI lighting

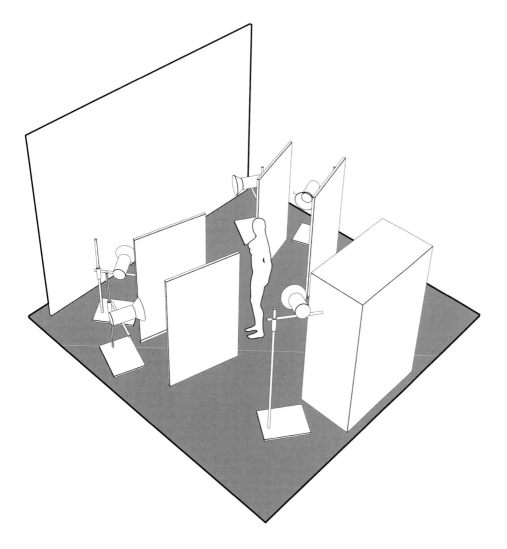

plan view

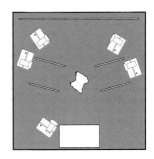

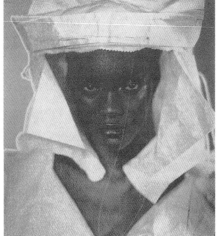

fine details

'Because I come from a movie background I don't have a standard lighting set-up,' says Patricia Canino. 'Every shot is different. I just put the lights where they give me the result that I am after. For me, lighting is like making a sculpture or a painting.'

This shot by Canino again uses sophisticated lighting to create a very theatrical and stylised effect. Note how the blue background brings out the cooler tones in the subject.

The model here is a make-up artist for Nina Ricci, who wanted a photograph that would show both his male and female sides. Try covering up first one side of the face and then the other, to discover how successful he's been in using his skills to alter his appearance.

To complement that treatment, photographer Karim Ramzi went for a clean, modern style. He used two flash heads in small pan reflectors to white out the bedsheet hanging behind as an improvised backdrop. The subject was lit by means of a single light in a small softbox over the top of the camera and a few metres from the subject, with a circular folding reflector below kicking light back into the shadows.

- Karim Ramzi
- Personal project
- Portfolio
- 6 x 6cm
- 150mm
- Kodak T-Max 100
- 1/500sec at f/11
- Electronic flash and softbox

plan view

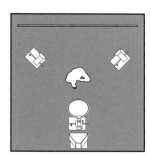

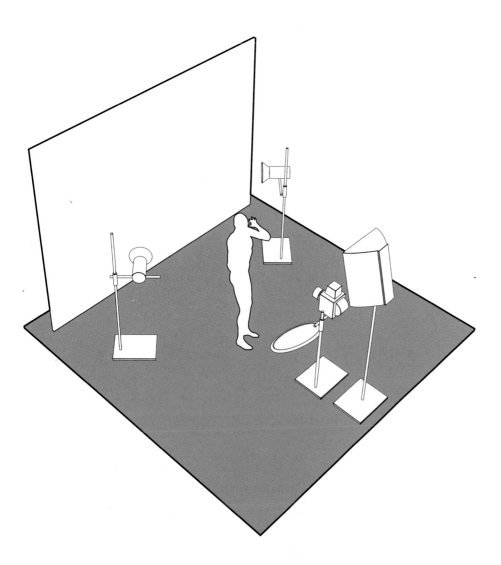

150 male and female

150 male and female

Clean, modern lighting helps to concentrate attention on the subject.

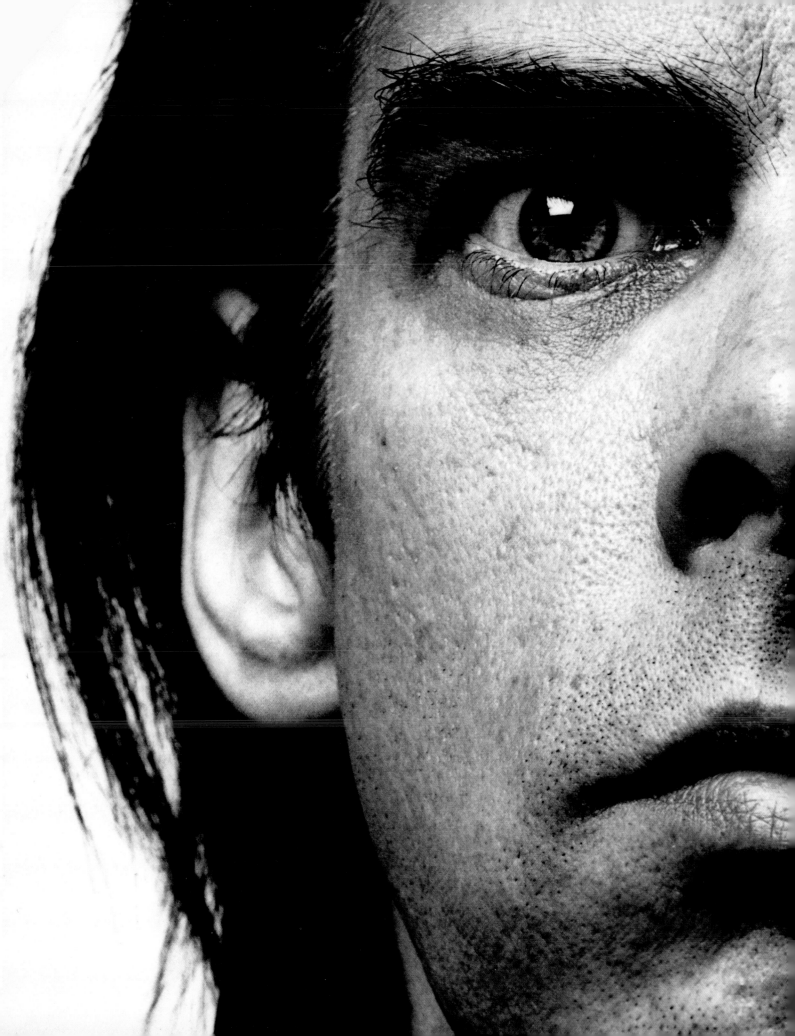

directory

photographer	Joachim Baldauf
address	Daniela Wagner Photographers
	Preysingstrasse 22
	81667 Munchen
	Germany
telephone	+49 (89) 489 0220
fax	+49 (89) 489 02217
email	kristina@danielawagner.de
website	www.danielawagner.de

Baldauf studied textile design in the German Alps before working as a graphic designer for the advertising industry, he came to photography through cover design. He loves the photography of the post-war years when very expressive results were achieved using the simplest means. In his work Baldauf aims to combine elegance, naturalism and humour. He enjoys the family atmosphere that comes from working within a tight-knit team, and he views his models as muses rather than empty, emotionless shells.

photographer	Patricia Canino
address	20 Impasse de Joinville
	75019 Paris
	France
telephone	+33 140 383 230
fax	+33 140 383 234

Patricia Canino is a Paris-based fashion photographer with a unique style based on lighting for film.

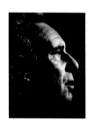

photographer	Fin Costello
address	11 Windlesham Avenue
	Brighton
	East Sussex BN1 3AH
	England
telephone	+44 (0)700 533 4279
email	fin@fincostello.co.uk
website	www.fincostello.co.uk

Costello has been a photographer since the late 1960s, specialising in portraiture. Most of his work is done for the music and magazine industries. 'There are two streams to what I do, the first being simple portraits such as those in this book, and more involved theatrical pictures such as record covers I have done for the rock singer Ozzy Osbourne. For many years I specialised in black & white portraits, where my influences were Richard Avedon, Bill Brandt and W. Eugene Smith.' During the 1980s Costello won several awards (album cover of the year) for this style of work. He particularly likes to print his own black & white pictures. Since the advent of digital imaging, in particular Adobe Photoshop, he has developed a more theatrical style. 'I will often shoot several elements of the picture separately and comp them together in the Mac.' He has worked with artists such as the Rolling Stones, Michael Jackson, Sting, Aerosmith, Kiss and many other bands. Publications which have commissioned him include the Independent, the Guardian, C4TV, Time magazine and most of the music magazines worldwide. Costello's archive pictures are marketed by Redferns Music Picture Library, which can be reached through info@redferns.com

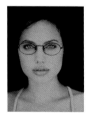

photographer	Jeff Dunas
address	9060 Santa Monica Boulevard
	Suite 370
	Los Angeles
	CA 90069
	USA
fax	+1 (310) 289 1717
email	jrdphoto@dunas.com
website	www.dunas.com

Dunas is an editorial and advertising photographer working in the portrait, beauty and reportage areas. His personal pursuits include nudes, portraits and documentary photography. 'I have been photographing nudes for over 20 years. This has been a dominant personal fine-art pursuit and a long and satisfying photographic exploration. Portraits are a very fulfilling photographic direction for me. One of the aspects of portraiture that pleases me enormously is its ability to freeze time, allowing observation that would not be possible in reality.' Unlike many photographers, Dunas seeks diversion with a camera. He has been shooting street pictures in Paris, New York and elsewhere for 15 years at every opportunity.

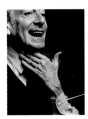

photographer	Mark Guthrie
address	3 Pennethorne Close
	London E9 7HF
	England
telephone	+44 (0)20 8986 2214
fax	+44 (0)20 8986 2214
mobile	+44 (0)973 834873
email	markguthrie100@hotmail.com

Mark Guthrie has been a photographer for five years. He went freelance after doing an MA in Image and Communication at Goldsmiths College. Since then he has been concentrating on editorial portraiture, working for most of the weekend broadsheet supplements, as well as being heavily involved in the setting up of a new lifestyle title called Untold. His style involves using a basic lighting set-up, being reasonably close to the subject and getting the maximum amount of animation out of them by talking to them. 'I find this approach enables me to get a lot of drama out of the subject,' says Guthrie. He has recently begun to branch out into advertising work. To date he has done the launch campaign for Sky Digital with M&C Saatchi and several commissions for Tango with hhcl+partners.

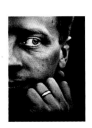

photographer	Nigel Harper
address	The New Barn
	Eythrope Rd
	Stone
	Aylesbury
	Buckinghamshire HP17 8PH
	England
telephone	+44 (0)1296 747747
fax	+44 (0)1296 747747
email	mail@nigelharper.com
website	www.nigelharper.com

Harper has been a full-time professional photographer for 13 years. 70 per cent of the business is wedding photography. He works hard to bring a fresh style to his work, employing ideas gleaned from film and television. Using Fuji and Kodak film, he has won over 200 professional awards. Harper gained his Associateship with the MPA in 1993 and with the BIPP in 1994, and was also awarded Craftsman with Distinction by the Guild of Wedding Photographers. His approach to wedding photography embraces photojournalism, reportage and a touch of classical style. It is a mix, which has produced a successful and individual style. When the opportunity arises, he likes to create dramatic photographs, with impact, utilising motion blur or special lighting effects. Harper has lectured around the UK and abroad for many years and continues to impart his knowledge and demonstrate his style to fellow photographers. He uses Bronica 645 cameras with lenses from 30mm fisheye to 150mm telephoto, and Canon EOS cameras are used primarily for black & white. Harper now increasingly uses the Fuji S1 Pro Digital camera for wedding photography and all his portraiture.

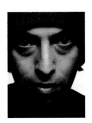

photographer	Hiroshi Kutomi
address	Flat D
	141 Hertford Road
	London N1 4LR
	England
telephone	+44 (0)20 7249 0062
fax	+44 (0)20 7249 0062
email	hiroshi.kutomi@virgin.net

Born in Tokyo in 1970, Hiroshi Kutomi moved to London in 1996. After assisting Nick Knight full-time for two years he became a freelance fashion photographer in 1999, working for magazines including i-D, Vogue (UK and Japan) and Glamour.

photographer	Mark Leightley
address	The Studio
	Braeside
	St Sampsons
	Guernsey GY2 4FF
	Channel Islands
telephone	+44 (0)1481 249719
fax	+44 (0)1481 241123

Born in Portsmouth in 1954, Mark Leightley has lived with his family in the small Channel Island of Guernsey for the past 20 years, entering professional photography in 1988. Today, his fresh and creative approach has placed him among the leading social/portrait photographers, and he is one of only a few to specialise in pictures of people. The winner of countless major awards, he is a member of the prestigious Kodak Gold Circle and a past Kodak Family Portrait Photographer of the Year. When not behind the camera, he lectures throughout the British Isles and overseas, sharing his skills with fellow photographers.

photographer	William Long
address	Longshots Photography
	PO Box 2333
	Fortitude Valley BC
	Brisbane
	Queensland 4006
	Australia
telephone	+61 738 934 007
fax	+61 738 934 001
email	wlong@powerup.com.au
website	www.longshots.com.au

Originally from the UK, William Long emigrated to Brisbane, Australia, and since then has built up an ever-increasing list of local, national and international clients in the commercial, fashion, industrial and advertising industries. His work has been widely published in everything from advertising and marketing material to leading newspapers and magazines. He has won numerous awards, including Portrait Photographer of the Year 2000 from the British Institute of Professional Photography. 'Creative, almost choreographed images, give me the opportunity to express profound emotions,' he says, 'and to make an impact on the viewer's mind. The use of light and drama from the theatrical perspective, intentionally or subconsciously, influences all of my work. My intention is to make a difference, to make an impact, to produce a response.'

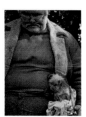

photographer	Jo McGuire
address	6 Francis Avenue
	Feltham
	Middlesex TW13 4EB
	England
telephone	+44 (0)20 8893 2516
email	jo@mcguire2000.fsnet.co.uk
website	www.mcguire2000.fsnet.co.uk

Jo McGuire is an award-winning freelance photographer specialising in documentary portraiture using natural lighting and a candid approach. Her work has appeared in a range of publications, including the Sunday Times, and she is available for commissions. One of her most accomplished projects to date – a photographic study of British Gypsies – has been widely acclaimed, and she is working towards producing a book on the subject.

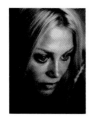

photographer	Matt Moss
address	The Mill House
	35 Mill Road
	Marlow
	Buckinghamshire SL7 1QB
	England
telephone	+44 (0)1628 486711
fax	+44 (0)7970 570710
mobile	+44 (0)7976 966114
email	mattmoss44@hotmail.com
website	www.matt-moss.com

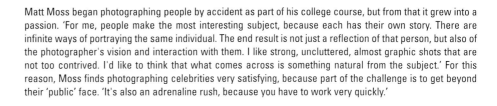

Matt Moss began photographing people by accident as part of his college course, but from that it grew into a passion. 'For me, people make the most interesting subject, because each has their own story. There are infinite ways of portraying the same individual. The end result is not just a reflection of that person, but also of the photographer's vision and interaction with them. I like strong, uncluttered, almost graphic shots that are not too contrived. I'd like to think that what comes across is something natural from the subject.' For this reason, Moss finds photographing celebrities very satisfying, because part of the challenge is to get beyond their 'public' face. 'It's also an adrenaline rush, because you have to work very quickly.'

photographer	Pauline Neild
address	20 Dennison Road
	Cheadle Hulme
	Cheshire SK6 6LW
	England
telephone	+44 (0)7710 095273
email	pauline@pneild.freeserve.co.uk

Pauline Neild's career in photography started ten years ago. Initially she worked for a local paper creating images in black & white. She moved on to shooting in colour whilst working for the Manchester Evening News. Neild also began to work for the Times Educational Supplement and for Camera Press, an international press agency based in London. She won awards in the British Pictures Editors Awards two years running; the first award for black & white work, the second for feature work. 'As well as press work I take on both short- and long-term commissions for the North West Arts Board, local councils, PR companies, schools and colleges, museums and art galleries, theatres and local businesses. I enjoy finding unusual and striking images in ordinary situations.'

photographer	Erwin Olaf
address	Ijseltraat 26–28
	1078 CJ Amsterdam
	The Netherlands
telephone	+31 20 692 3438
fax	+31 20 694 1291
email	eolaf@euronet.nl
website	www.erwinolaf.com

Erwin Olaf is a leading Dutch photographer who started his working life in photojournalism but now shoots mainly fashion internationally. His images are hallmarked by visual humour and persistent allusions to the formal expressions of art. Clients include Heineken, Silk Cut, Hennessy and Diesel.

photographer	Karen Parker
address	87 Wolverton Road
	Stony Stratford
	Milton Keynes MK11 1EH
	England
telephone	+44 (0)1908 566366
email	karen@karenparker.co.uk
website	www.karenparker.co.uk www.karenparker.net

Karen Parker, UK Digital Photographer of the Year 2000/2001, provides a service that is unique in the UK. She has won many portrait awards, including a prestigious Kodak Gold Award, and these signify the creativity she strives for in both her commercial and personal portrait work. Specialising in portraiture and working regularly from concept to shoot, including retouching, means she's regularly in demand from a diverse range of businesses. However, Karen is also at the forefront of technology as she's recently invested in a digital back, allowing clients to view results within seconds and/or email them during a shoot. In a real emergency, studio shoots can even take place at any hour. This level of service means everything is in-house and very personal – or, as Karen puts it: 'Maybe it's time to believe the hype.'

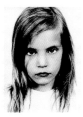

photographer	Tamara Peel
address	58 Worcester Street
	Stourbridge
	West Midlands DY8 1AS
	England
telephone	+44 (0)2380 898301

Tamara Peel, recognised as one of Europe's leading portrait photographers, has won prestigious Agfa, Fuji and Kodak awards for her work. Having studied art and design extensively and gaining an Honours Degree in Photography at Manchester, she set up her own studio in Stourbridge, England. Tamara likes to produce high-quality black & white and sepia-toned portraits, and is also an accomplished wedding photographer.

photographer	Karim Ramzi
address	5 Rue Taylor
	75010 Paris
	France
telephone	+33 140 407 877
fax	+33 140 407 877
email	karim@karimramzi.com
website	www.karimramzi.com

Based in Paris, France, Karim Ramzi is world-renowned for his fashion and portrait work. For over a decade, he has been photographing models and celebrities around the world, including Europe, the USA, Middle East, and South East Asia. The royal families of Saudi Arabia, Jordan, and Morocco have been among his famous subjects. Initially self-taught, through reading books and magazines and attending seminars and exhibitions, he later studied with some of the world's leading photographers, including Youssef Karsh in Canada. Karim Ramzi has a knack for bringing out the best in his subjects, whether they are famous fashion models, kings or ordinary people. He tries capturing the true essence of the people with whom he works, so the images look real, not posed and artificial.

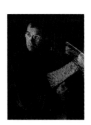

photographer	Llewellyn Robins
address	The Camera House
	34 High Street
	Hungerford
	Berkshire RG17 0NF
	England
telephone	+44 (0)1488 680790
fax	+44 (0)1488 680791
email	llewellyn@lrphotography.co.uk
website	www.lrphotography.co.uk

Llewellyn Robins, FBIPP, FRPS, QEP runs a portrait and wedding photography studio in Hungerford, England. He has a fellowship from the British Institute of Professional Photography and the Royal Photographic Society. He has also been awarded the honour of Qualified European Photographer. Though best known for his Romantic style of portraiture, his work has more recently shown a harder edge, most noticeably with his corporate portraiture of artists in black & white. His many styles of portraiture have won him numerous awards all over the world, and he is often asked to lecture on his distinctive style both in the UK and the USA.

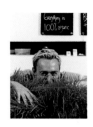

photographer	Dennis Schoenberg
address	45 Melville Court
	184 Goldhawk Road
	London W12 9NY
	England
telephone	+44 (0)20 8740 6065
email	d_schoenberg@hotmail.com

Born in Germany, Dennis Schoenberg started taking pictures from the age of 16 and now lives and works in London. Having assisted Rankin and Wolfgang Tillmann, and spent some time in New York, his work is now mainly editorial, and has appeared in publications as diverse as Sleaze Nation and Tatler.

photographer	Regina Schmidt
address	138A Preston Drove
	Brighton
	East Sussex BN1 6FY
	England
telephone	+44 (0)7970 924690

After working for fashion and music photographer Axl Jansen in Germany, Regina started a BA in Advertising and Editorial Photography at Kent Institute of Art and Design. For her final show she teamed up with three friends and organised four different venues for a simultaneous European photographic exhibition 'closer'. 'The basic idea was to bring contemporary photography to the public, entering their space and de-mystifying the "art aura". The events were aided by digital technology and the photographs were simultaneously printed on location and hung ad hoc,' says Regina. Since graduating in July 2000, she has continued to work in the field of music, fashion and portraiture. Amongst the assignments she has been commissioned are CD covers in Germany, film stills for a movie in London, portraits of the chairman of Nestlé UK plus reportage-work for the Brighton Source magazine. She has also done fashion-work for London-based menswear company Science. Regina is currently working on a personal project with the view of presenting a touring exhibition in the forthcoming year.

photographer	Tobias Titz
address	Valley Str. 25 RGB
	81371 Munchen
	Germany
telephone	+49 (89) 77 92 47
fax	+49 (89) 76 70 14 85
email	tobititz@gmx.de
website	www.tobiastitz.de

Born in 1973, Tobias Titz is a Münich-based freelance photographer whose work has appeared in publications such as Spiegel, Groove and Seven magazine. In 2000 he was a winner in the first International Polaroid Awards. 'My idea behind the Polaroid series was to get away from the usual separation between the people being photographed and the final photo print. I wanted to give people the chance of being creatively involved in the photographing process. Directly after the photo has been taken the persons are given the negative and are free to scratch into it their statement. This enables them to be, in a sense, active co-creators in the project.' This series of photographs is an ongoing project.

photographer	Linda Troeller
address	Hotel Chelsea
	222 W 23rd Street
	New York
	NY 10011
	USA
telephone	+1 (212) 647 9808
fax	+1 (212) 675 5531
email	troeller@bway.net
website	www.LindaTroeller.com

Linda Troeller is an art and editorial photographer living in New York City. She has won prestigious awards for her photo-collage series, TB-AIDS DIARY, from the Friends of Photography Ferguson Award; and Book Award of Excellence for Healing Waters, Aperture from the Pictures of the Year, 1999. Her new book, Erotic Lives of Women, Scalo Publishers, was hailed in the NYT Book Review as 'one of the best erotic books of the decade.' She lectures worldwide with workshops upcoming: 'Links to Photography', International Summer Art Academy, Salzburg, July 23–Aug 11, 2002. She is currently working on a book on the Hotel Chelsea in New York City and a fashion commission for Apolda Avant-Garde Museum, Germany.

photographer	Neil Warner
address	Warner Corporate Photographer
	Warner Digital, Menlo Hill,
	Galway, Ireland
telephone	+353 91 751815
mobile	+353 (0)87 2596304
email	neil@warnerphoto.org
website	www.warnerphoto.org

Warner Corporate Photography is a specialist company servicing business in Ireland. Founded as a marketing support company, it produces photography specifically for the business sector. Neil Warner AIPPACr ABIPP AMMII is the principal of the company and Managing Director of Irish National Corporate Photography and Digital Imaging – the parent of Warner Corporate Photography and its sister company Warner Digital Imaging and the utility site www.irishonlinephotofile.com. The photography of Warner Corporate Photography is principally used in annual reports, corporate brochures, sales brochures, exhibition stands, audio-visual presentations and Web Site development, through a network of associated companies in corporate graphics, web design and corporate video. Together with its service partners, Warner Corporate Photography can provide a customised solution to meet its clients needs. Thus Warner Corporate Photography is a one-stop shop with all the advantages of providing a diverse range of services without the attendant overheads of bigger companies.

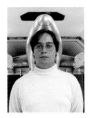

photographer	Paul Wenham-Clarke
address	Paul Wenham-Clarke, FBIPP
	56 Sycamore Rise
	Newbury
	Berkshire RG14 2LZ
	England
telephone	+44 (0)7000 785582
fax	+44 (0)7000 785582
mobile	+44 (0)7721 902670
email	paul@wenhamclarke.com
website	www.wenhamclarke.com

At 37 years of age, Paul Wenham-Clarke has been involved in photography all of his working life. He studied photography at Berkshire College of Art and Design (now Reading College) when he was 18. On leaving the course he worked as an assistant for three years and then became a self-employed commercial photographer at the age of 24. Paul later returned to his old college to teach part-time on the HND/BA course in Photography and Digital Manipulation. 'Over the years my work has changed a good deal. Early on in my career I was known as a still-life photographer, but now I nearly always shoot people, which I enjoy much more. My main aim is to create images that are fun, effective and eye-catching. I love strong composition and playing with perspective and focus. Typically my work covers three main areas: location portraits; quirky and humorous advertising images of people; and dramatic industrial images.'

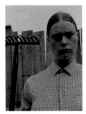

photographer	Marianne Wie
address	42 Caterham Road
	London SE13 5AR
	England
telephone	+44 (0)20 8297 9647
mobile	+44 (0)7799 402595
email	mariannewie@hotmail.com

'I am inspired by many 19th-century photographers and painters. My work is about time and representation of time. I enjoy "ageing" my work by finding appropriate props and location and experimenting in the darkroom.' Marianne came to London from Norway in 1992 and studied Sculpture at Chelsea College for four years. In her last year her work became more photography-based. She went on to study the technical aspects of photography and now works as a photographer's assistant.

photographer	Dave Willis
telephone	+44 (0)1628 819008
fax	+44 (0)1628 819008
mobile	+44 (0)7831 821155
email	info@davewillis.co.uk
website	www.davewillis.co.uk

'I originally started shooting live gigs for the Melody Maker and the rock magazine Kerrang! After a few hundred gigs, a broken nose and the onset of imminent deafness, I thought I might have a go at studio and location music photography, as it was safer and probably a lot less painful!' Now Willis spends most of his time shooting mainly pop bands, film directors and actors, although he says, 'I still do the odd dodgy rock band just to keep my hand in!'

would you like to see your images in future books?

If you would like your work to be considered for inclusion in future books, please write to: The Editor, Lighting For..., RotoVision SA, Sheridan House, 112/116A Western Road, Hove, East Sussex BN3 1DD, UK. Please do not send images either with the initial inquiry or with any subsequent correspondence, unless requested. Unsolicited pictures may not always be returned. When a book is planned which corresponds with your particular area(s) of expertise we will contact you.

acknowledgements

Thanks must go, first and foremost, to all of the photographers whose work is featured in this book, and their generosity of spirit in being willing to share the knowledge and experience with other photographers. Thanks also to those companies which were kind enough to make available photographs of their products to illustrate some of the technical sections. Finally, enormous thanks must go to the talented team at RotoVision, including Commissioning Editor Kate Noël-Paton and Assistant Editor Erica Ffrench; to Ed Templeton and Hamish Makgill from Red Design for their stylish layout; and to Sam Proud from Mosaic for his clear and elegant illustrations.